Palgrave Studies in Alternative Education

Series editors
Helen Lees
Education
Newman University
Birmingham, UK

Michael Reiss
UCL Institute of Education
University of London
London, UK

This series emerges out of a recent global rise of interest in and actual educational practices done with voice, choice, freedoms and interpersonal thoughtfulness. From subversion to introversion, including alternative settings of the state to alternative pathways of the private, the series embraces a diverse range of voices.

Common to books in the series is a vision of education already in existence and knowledge of education possible here and now. Theoretical ideas with potential to be enacted or influential in lived practice are also a part of what we offer with the books.

This series repositions what we deem as valuable educationally by accepting the power of many different forces such as silence, love, joy, despair, confusion, curiosity, failure, attachments as all potentially viable, interesting, useful elements in educational stories. Nothing is rejected if it has history or record as being of worth to people educationally, nor does this series doubt or distrust compelling ideas of difference as relevant.

We wish to allow mainstream and marginal practices to meet here without prejudice as Other but also with a view to ensuring platforms for the Other to find community and understanding with others.

The following are the primary aims of the series:

- To publish new work on education with a distinctive voice.
- To enable alternative education to find a mainstream profile.
- To publish research that draws with interdisciplinary expertise on pertinent materials for interpersonal change or adjustments of approach towards greater voice.
- To show education as without borders or boundaries placed on what is possible to think and do.

If you would like to submit a proposal or discuss a project in more detail please contact:

Helen Lees and Michael Reiss h.lees@newman.ac.uk & m.reiss@ucl.ac.uk or Eleanor Christie Eleanor.Christie@palgrave.com.

The series will include both monographs and edited collections and Palgrave Pivot formats.

More information about this series at
http://www.springer.com/series/15489

Stewart Riddle · David Cleaver

Alternative Schooling, Social Justice and Marginalised Students

Teaching and Learning in an Alternative Music School

Stewart Riddle
School of Teacher Education and Early
 Childhood, University of Southern
 Queensland
Springfield Central, Queensland
Australia

David Cleaver
School of Linguistics, Adult and
 Specialist Education, University of
 Southern Queensland
Springfield Central, Queensland
Australia

Palgrave Studies in Alternative Education
ISBN 978-3-319-58989-3 ISBN 978-3-319-58990-9 (eBook)
DOI 10.1007/978-3-319-58990-9

Library of Congress Control Number: 2017943646

Cover illustration: Abstract Bricks and Shadows © Stephen Bonk/Fotolia.co.uk

Printed on acid-free paper

This Palgrave Macmillan imprint is published by Springer Nature
The registered company is Springer International Publishing AG
The registered company address is: Gewerbestrasse 11, 6330 Cham, Switzerland

This book is dedicated to Eilish, Renée, Vincent and Livian.

ACKNOWLEDGEMENTS

We would like to express our sincere gratitude to the students, their parents and staff of Music Industry College, for allowing us to come into their school community and spend time talking, listening, watching and writing about their lives and experiences. In particular, the school principal, Brett Wood, was warmly welcoming and very patient with us over the five years that we spent poking around the school. We would also like to thank the University of Southern Queensland for providing us with seed funding in 2011 to begin the pilot project, followed by a faculty research grant in 2012, as well as research assistant support funding in 2015. These funding opportunities made all the difference in gathering and analysing a wide range of data that we might not have been able to do otherwise. We would also like to acknowledge the university providing study leave to us both in the final stages of the manuscript preparation, which gave invaluable space and time to bring the book together. Thanks also go to the three research assistants over the course of this project, who helped us to collate data, transcribe interviews and keep us organised, including Renée Herd, Jodie Amos and Rebecca Mesken. We would like to acknowledge the support and encouragement that our colleagues and comrades have provided, including Martin Mills, Glenda McGregor, Patrick Danaher, Amanda Heffernan, Katie Burke, as well as the many friends and associates who were there to listen, offer advice or a cold drink when we needed it. Most importantly, thanks go to the loving patience and support of our families, who gave us the time and space to write this book.

CONTENTS

A Day in the Life at an Alternative Music School

Abstract This chapter commences with a narrative account of a *day in the life* at Music Industry College, before outlining the key themes and main arguments being presented in this book. The contemporary schooling context in Australia is introduced, and an overview of Music Industry College is presented. Key concepts, such as social justice, marginalised youth, and contemporary education policy are introduced. This chapter also details the research methodology and provides an outline of the structure of this book.

Keywords Schooling · Social justice · Education · Narrative · Case study · Marginalisation

Music Industry College (MIC) is housed in a recently refurbished double-story building tucked away on a side street in Fortitude Valley[1]. "The Valley" is Brisbane's bustling music and entertainment precinct, and a rather bohemian urban context seems appropriate for a school that is out of the ordinary. MIC nestles among cafes, late night bars and clubs, and a bustling China Town precinct is just around the corner. Vibrant street life scenes blend in with rows of high-rise office buildings. During the day, workers dodge taxis and chewing gum on beer-stained pavements while scurrying about looking for coffee.

The MIC venue, a converted recording studio, is wedged between a commercial catering company on the one side and music management

© The Author(s) 2017
S. Riddle and D. Cleaver, *Alternative Schooling, Social Justice and Marginalised Students*, Palgrave Studies in Alternative Education, DOI 10.1007/978-3-319-58990-9_1

offices on the other. The unassuming street frontage belies the vitality and creativity of the learning community inside, which is a school by day and a music venue by night.

Music Industry College is a senior high school (years 11 and 12 in the Queensland education system) designed to attract and support students who are passionate about music and interested in learning about the contemporary music industry. While high school music industry colleges are rare, what contributes to MIC's uniqueness is that many students are here because they have been excluded from mainstream schools, are disenfranchised, have been at a loss about purpose or have just plainly opted out—and the school is designed to re-engage them. MIC not only prepares students for the creative industries, but also allows marginalised, disengaged and often troubled youth to re-engage in learning, and most importantly, to find themselves. While we are a couple of rock musician-come-academics, our ethnographic case study collaboration with MIC captures our passion for music and our interest in creative teaching and learning.

Today, we are here to learn more about a day in the life at MIC. Walking through the front door, we are greeted warmly by Brett, the school principal. He immediately launches into an enthusiastic recount of the previous evening's school "gig". The entire performance was designed, developed and produced by 16- and 17-years-old students, with only a little support from the teachers and parents. "It's completely their gig, and the adults just do what we're told", Brett explains. A roaring success, with good attendance by the community of friends and parents, now means that the show's net profit can be invested into more studio recording equipment and help to cover a range of film production expenses.

It is 10 in the morning and classes are about to start for the day. A hum of chatter flows throughout the building. Brett wants to show us the top floor and we merge into the narrow stairwell with a group of laughing students. Above, in an open plain, large room, we see students hanging around in small groups, some talking about the gig, others sitting together sharing headphones plugged into laptops, looking at music videos, listening to music, some intently discussing their English assignment. Others are out socialising on the balcony while taking in the warm Brisbane spring morning sun.

The school is instantly recognisable as open in terms of space, feel and ideas. An earlier discussion with Brett comes to mind, where he explained that "the bullshit of territorialism created by teachers in most schools is missing here". Glass walls and doors reveal the spaces where

students are sitting, some at desks in a traditional-looking classroom format and some in other areas on sofas strumming guitars or with laptops and headphones.

Returning down the stairs, we head to the *Powderfinger Room*[2] for Year 11 Music, the first lesson of the day. The room has acoustic panelling walls on the side, sliding glass walls at the front and back and is modular; it can be broken into two separate spaces. All the chairs are on wheels, some with small arm desks attached, sliding around the room as students come in ready for the session. There is a colourful and eclectic range of identities: curly hair, pink hair, mohawk, shaved head, long fringe, black hair, bow tie, tattoos. Laptops come out, earbuds and studs are in, students are talking to each other as they wait for the music lesson to begin. From our conversations with students, we quickly learn that most don't want to be told how to dress and freedom with visual identity at MIC has been a great release from the constraints and restrictions imposed in some of their previous schools.

Some students are in the middle of the room with arm desks, while others sit alongside the bench at the side of the room. More sit together around the group tables. There is a whiteboard at the front as well as a large TV connected to the teacher's computer. A small stage with a public address system fills one corner of the room. This classroom by day converts into a venue by night, and often during lunch breaks as well. There are stage lights hanging from various lighting bars in the room. These aren't currently on, just some fluorescent bars for this morning's lesson. We are sitting up the back, where there is a digital mixing desk console packed away into the corner.

The lesson starts with the roll call. There are two teachers in the room: the music teacher, Charles, and maths teacher, Kristin. Aural studies begin—we have "10 chords". Groans ensue and laptops open. Piano chords are played, followed by a checking of responses with the students—hands up how many out of 10? Charles asks for laptops to be shut again and reminds students that their composition tasks are due. Moving on—there are whoops and cheers when Charles digresses to announce that he is a new dad. "Who wants to see some pics of the new baby?" Shouts of assent. Charles proceeds to display photographs of his baby girl on the big TV but then moves seamlessly back to the lesson focus and reminds students that their musicology draft is also due. There are some good, interjected "dad jokes" and we get a feel for the warmth in the room—relaxed and humorous but also with engagement and commitment from both students and teachers.

After explaining the details of the musicology assignment, the remainder of the lesson is spent with the students working individually on tasks, while Charles and Kristin walk around the room offering assistance. The students are free to move about the room. Some go outside, some into the hallway. Laptops open, working, chatting, sharing, helping. The glass walls feel a little like we are in a fishbowl. As people come past, they peer in, we look out and wonder how the students don't get constantly distracted. Someone pulls out their smart phone and takes a photograph of the class.

Suddenly, the fancy coloured bar lights come on, and now it really does feel like a music venue! Some official government folk are wandering around on a tour accompanied by Brett who proudly shows off the school. A student grabs an acoustic guitar and he plugs it into a portable recording device. Another checks her phone, while a third goes off to the bathroom. A boy is staring off into the distance, perhaps deep in thought about the task, perhaps reflecting on last night's gig.

David[3]—from my observational position at the back of the class I reflect and become acutely aware of my purpose here as an academic investigator and observer. Fortunately, the students seem nonchalant, even unaware of the presence of Stewart and myself—hardly a second glance. I think this reflects the comfort they feel with their teachers and visitors and in 'just being here'. I reflect on how this scene contrasts with my days as a high school teacher and I recall resonant thoughts to a comment by Glenda McGregor[4]—about democracy and neoliberalism and like her too I recall how I got into teaching because I believed that schools were 'transformative institutions of human possibility rather than factory-like producers of human capital'. Prior to university teaching, when engaged as a classroom teacher I quickly understood the expectation was that I would help 'mould' each student into becoming a particular type of person because that was part of the educational agenda at the school. But here, at MIC the agenda for students is to explore possibility and certainly to become what you want to be. My feelings are stirred as I have fleeting contrasts to my early schooling and the way I was taught. That narrative would be closer to Tom Brown's Schooldays than anything taking place here.

James, the Film and Television teacher, arrives. He announces the names of those students who have earned detentions. Detention?! We immediately become interested in the way ground rules and penalties work in the school. James continues and we learn that some of the infractions are for missing class, being late, leaving without telling anyone or getting

clearance from parents, leaving laptops out or refusal to obey instructions (this is very rare, we later discover). A list of 10 names goes up on the board, together with the detention durations. The lesson comes to an end and it is morning tea.

For the next lesson, Year 11 English, we move upstairs to a much smaller room with the same number of students. It is cosy to the point of being crowded. Music posters adorn the walls. There are multiple rows of tables facing the front, some students sitting on the floor, others at the tables. We're in the *Grates Room*. We can see through the glass walls to the *Regurgitator Room* next door. Again, there are two teachers in the room: Charlie, the English teacher, being assisted by James. Charlie stands at the front, giving general feedback on drafts and providing information on what students need to do to complete the task. Because of our timing (November), the students are in the middle of their final set of assignments and there isn't a great deal of new work being introduced at this point. Despite a feeling of urgency about completing assessments, there is still a relaxed and casual atmosphere in the room.

Charlie connects his phone to the big television and shares the list of students presenting their orals next week. The students are then broken into two groups, with one group moving into the *Regurgitator Room* next door. Students are working individually on their assignments but are also chatting to each other, and some have headphones on. They are working on their individual oral assignment scripts. In the room behind us, which we can see through the glass wall, a handful of Year 12 students are doing independent work, being tutored by Ed, the business teacher.

During the lunch break, we conduct interviews with individual volunteer students and then we're back downstairs in the *Powderfinger Room*, the classroom/live music venue and walking in about 5 min before Year 11 Maths is due to start, we're greeted by a dance party. The DJ is on the mixing desk, while the PA is cranking out beats and a group are dancing around in the middle—this is a rave party. A guitarist cranks it up through a powerful amplifier, and another is working at the lighting desk. The fluorescent lights are off and the disco lights are flashing. We are informed that this is a regular lunchtime routine.

Perhaps surprisingly, the room comes quickly to order as the mathematics teacher, Kristin, enters and the class begins for the afternoon. She asks for laptops to be shut and for "no technology to be opened until we're ready to do so". Once again, students are spread throughout the double room in various places and configurations of desks and chairs. A

box of calculators and rulers gets passed around the room. This is the last maths lesson of the unit, with new content for the first half an hour and then the rest of the lesson is to be spent on revision for the upcoming exam. Kristin says with a wry grin, "We're going to be a little old school today. It will be handy if you have access to a pen or a pencil".

As we have witnessed throughout the day, the students seem relaxed and engaged in the lesson. Kristin demonstrates an example on the whiteboard, then students are given time to work on handouts to complete the problem. After that, the students are given time to individually practice plotting and graphing.

The lesson comes to an end and we head out into the busy "Valley" street. We are always enriched by our visits, but this time a little more excited and a just a little exhausted—glad to have had the opportunity to spend a day in the life of a Year 11 student at MIC.

Our relationship with MIC began in 2011, when Brett first invited us into conduct a series of focus groups and interviews with students and teachers. At the time, the school was in its second year of operation but at its original venue. This was the rather makeshift upstairs set of rooms at the Fortitude Valley Police Citizens Youth Club. We were instantly captivated by the whole concept of the school and have returned many times since to conduct interviews, attend lessons, collect survey responses and other research-related documents, and to do the kind of fieldwork practiced by researchers interested in ethnographic accounts of people's lived experiences.

From the beginning, we were drawn in by the cohesive sense of community, the ethos and shared values of all who belong to MIC. From our work to date, we have presented our research at international education conferences as well as publishing papers on: the centrality of Brett's vision and school leadership,[5] the important of music for gluing the school together,[6] the school community and culture[7] and the ways that the school staff navigate complex policy terrains of schooling in Australia.[8] Now, with this culminating venture, we draw together our insights from our time at MIC in an attempt to speak to what we see as some of the most pressing issues of contemporary schooling.

We present our understandings of the nature of MIC and its important work as a site of social justice in practice, of how the staff work to engage young learners, particularly those who have been marginalised and disenfranchised from their previous schooling experiences. Importantly, we critically hold the philosophies and practices of MIC

up against current trends, which are not confined to Australia but have global parallels, in educational policy, politics and ideology. We explore much by considering how MIC utilises alternative ways of working and how it creatively works within and against the grain of policy simultaneously in order to actively re-engage students in their learning and in their lives.[9]

As a collaborative endeavour, this book is written from the inclusive *we* perspective. While both David and Stewart bring their own experiences and politics into the writing mix, this is a collaborative project and our voices join together in a series of collective enunciations, which we present as arguments, propositions and provocations. At this point, we offer some of our backgrounds in the form of narratives of personal history and experience in order to reveal our own positioning as researchers, educators and musicians. These are designed to give a sense of where we are coming from, politically and ethically, while revealing influential and formative factors leading up to the MIC project and why we became interested in writing about alternative schooling and social justice in education.

DAVID

The following personal detail is just one possible narrative of many about my school days. There is much that I fondly remember and appreciate about the positive contributions of school life to my becoming. So, if there is a bitter taste from the ingredients for the narrative that follows, it is only the parts isolated to reveal some background leading to my interest in education and social justice.

My youth was spent in a variety of boarding schools, commencing at the age of 7. Both at primary and high schools, I experienced the dominance of tough authority controlled by corporal punishment and coupled with a strict religious "education" and rigid moral conditioning. Regimentation of life was closer to a military model than what one might now classify as a specific learning institution designed for kids. A blind eye was turned to regular bullying and as a feature of life it was deemed part of "toughening you up".

In one particular high school, it was the senior prefects who were authorised to mete out the caning for common infractions. Fortunately, my parents took me out of this school before I could graduate to become a prefect and therefore avoided receiving legitimate brutality

training through the thrashing of poor hapless juniors.[10] Since those days, I have come to believe that a rebellious nature, which thankfully was not entirely crushed, fostered much of my later direction.

At the first exposure to personal freedom, I "dropped out", grew my hair and joined a rock band. Later, after reading everything by Kerouac, Herman Hesse and *Deschooling Society* I breezed through some Jungian psychology to Alan Watts, Krishnamurti, Zen and Hinduism—specifically seeking personalised perspectives and alternative routes to spirituality, love and compassion—in ways different to all I had been exposed to. As my schooling had been trying to make me into something, without noticing what my personal interests and abilities were, I needed to reinvent my own capacity for personal growth. Many of my current perspectives about education are directed towards avoiding what I had experienced.

Later, when studying educational philosophy, I was attracted to the perspectives of theorists such as Freire, Montessori and A. S. Neill and particularly where they argue that we should respect and build upon individual interests. I felt at loggerheads with anything that smacks of a one-size-fits-all education. Philosophically, I became mindful of those aspects of education that include conditioning through control and authority and how these impact on autonomy, individuality and creativity. A catch-cry had become, "Better to teach children *how* to think rather than *what* to think".

STEWART

We moved around a lot when I was a kid, because my dad was serving in the Royal Australian Air Force, including living in Malaysia for a few years. I attended more public schools than I could count on one hand and I think that, for me, I was lucky because I never really struggled with the work and perhaps because of the constant change, I found it fairly easy to make new friends and find my own niche. I graduated from a public high school that had a reputation for housing some of the toughest kids in the local area, with nearly two-thirds of students coming from the lowest socio-economic quartile.

Music was a passion of mine from an early age, and by the time I was thirteen, I was forming my own little rock bands and dreaming of international stardom. When I finished school, I had no idea what I wanted to do apart from playing in bands, but eventually I decided to become

a high school English and music teacher by day, and continued to play in bands by night. I taught in a few different public and private schools, which came with many uncomfortable lessons about the enormous disparities between wealth and privilege, as well as how marginalisation and injustice can take on many forms.

One of the most confronting moments for me was when a Year 11 girl at a school for children from the Exclusive Brethren sect, where I taught for a couple of years, told me that she really wanted to be a teacher. You see, despite the fact that their community has significant financial and material wealth, they have a strict patriarchal social system that forbids members from things such as going to university, and where women play a subservient domestic role to the men. So it was a double-whammy for her, because not only was she forbidden from studying to be a teacher in the first place, her position in the community meant that she would not be able to make that choice even if it was available. That was when I realised that marginalisation, disenfranchisement, deprivation and disadvantage are not always linked to material poverty.

I came to education research through my desire to understand the importance of music in the lives of young teenagers who I was working with as a high school English teacher. One night I was at the Tivoli[11], where I was chatting with Brett, who I knew in my music world as a label owner and band manager, and he told me about this new school he was starting. And the rest, as they say, is history.

As collaborative colleagues, we decided to join research forces due to a resonance of our ideas, perspectives, politics and philosophies. We share a strong commitment to the centrality of social justice within schooling, which is evident throughout this book. We cohered when reading Connell, who argues that "social justice is not an add-on. It is fundamental to what good education is about".[12] We don't take this claim lightly. A commitment to social justice is a central framing of the teaching and learning conducted at MIC and is what has most interested us about the school. Therefore, social justice is a focal point of the work we have undertaken with the school over the past several years. Our collective philosophy also shares a commitment to the notions of democratic education and "education as care" and the associated dispositions that we see evident at MIC becoming a central feature of our discussion of educational policies and practices throughout this book.

Our exploration of the causes of social injustice in schooling has opened our eyes to critical theory and pedagogy and the work of scholars

such as Connell,[13] Freire,[14] McLaren,[15] Apple,[16] Giroux,[17] Noddings,[18] Smyth,[19] alongside many others. In particular, we draw on the rich tradition of research on social justice in Australian schooling, including seminal texts such as: *Making the Difference*,[20] *Schools and Social Justice*,[21] *Schooling the Rustbelt Kids*[22] and *Undemocratic Schooling*.[23]

The notion of social justice is highly contested and problematic, yet we have decided to make it a core focus of this book as we believe that the project of resisting educational inequality is far from complete. For the purposes of a working definition of social justice, we borrow from Fraser,[24] who conceptualises justice as greater than the commonly held understanding of a politics of redistribution (who gets how much of what—in this case, education), to include the notions of cultural recognition and political representation through parity of participation. The principles of democratic education and active citizenship are heavily invested in an understanding of social justice. It is not simply a project of giving the keys to access education to marginalised and disenfranchised young people, but about the project of actively reshaping education in the interests of those least advantaged by the system.[25]

An additional starting point was our shared passion for music. It had originally drawn us to MIC and continues to enhance our commitment to explore the importance of music in the lives of the young people who attend the school. A statement of observation from an earlier research publication reveals our initial enthusiasm for MIC and how it combines social inclusion, music and an alternative to mainstream education:

> The school attracts students who are passionate about music and music-related fields, but who have felt marginalised, disengaged and "turned off" in prior, mainstream school contexts, both public and private, and they seek refuge in the school as a way to both satisfy their passion for music and to successfully complete a high school education.[26]

In collaborating with MIC, our ethnographic case study agenda has been to look inside, to see, describe and bear witness to what is going on. We start within the particular context of MIC and we then look outward, in order to critically examine what is taking place against a backdrop of troubling issues in education and the subsequent effects upon students and teachers. We consider how the experiences and lives of people at MIC speak to the politics and governance of education, while also highlighting critical issues concerning matters of schooling and social justice.

We are concerned at the rate that students are "switching off, tuning out, and dropping out of high school"[27] and are interested in learning how alternative approaches might serve to re-engage students in learning,[28] to empower and switch them on through their particular interests and to help motivate them to possible and positive futures. Smyth and colleagues argue that we must rally against "the most pervasive and pressing educational issue confronting affluent Western countries—the disengagement, disconnection and tragic displacement from schooling of increasing numbers of young people, mostly those from backgrounds of disadvantage".[29] It is our hope that this book offers a small contribution to this project of switching marginalised and disenfranchised young people back on to their schooling.

We are also interested in resisting the idea that there are no alternatives[30] to how schooling might be done. We note the deeply troubling signs in how our education systems are becoming increasingly inadequate to the task of addressing the inequalities between different groups of learners. Political and economic structures engage in a maldistribution of funding and resources for schools, creating a tiered system of class and poverty injustices.

The issue of equity and access to a meaningful education[31] is something that we think is critically important. As such, our intention in this book is to provide some discussion, thoughts, perspectives and lines of possible hope for re-imagining the project of schooling more broadly, through a close analysis of the work of one particular school site. But why pick on one school, one case study? While our work with MIC represents a microscopic view into just one school context, what we have found are positive opportunities, insights and understandings, illuminating potential ways to address some of the multiple social and economic reasons why young people disengage from mainstream schooling. With MIC as an example, we counter some of the negative policies that are damaging for students and teachers,[32] and that shove our young people around,[33] treating them as waste products[34] of a flawed social–economic–political system.

Our work with MIC allows us to enter the debate into very serious matters of inequality and injustice in education and in the treatment of young people in Australia. In 2012, the trend had been identified by McInerney, when discussing educational disadvantage. He reminded us that the belief in an Australian egalitarian society had become a myth as 12% of Australian children were living in poverty and that "a widening

gap between the rich and poor, surging unemployment, and a mil-
lion people living in housing stress, are tangible signs that Australia is
becoming a more unequal and polarized society under the ascendancy of
neoliberal governance".[35] Under this governance, we have failed to sig-
nificantly reduce child and family poverty and to address the problems of
underachievement.[36]

There is little doubt that we live in troubled times. At the moment
of writing, war, terrorism, mass forced migration and displacement, rac-
ism, poverty, domestic violence, religious, political and cultural intoler-
ance and division, radicalisation and the disenfranchisement of youth
raise serious questions about the role that education can play in how our
societies can offer more justice, fairness and compassion, while advancing
the cause of a humanitarian, democratic and caring future. It seems clear
to us that business-as-usual is not going to be good enough. We need
a radical reimagining of the role of the public in generating collective
social good. Education generally, and schooling more specifically, must
be a central part of such a project.

We seek to contribute to the debate of what counts in education by
creating provocations and to trouble certainty about the forces that are
impacting on schooling in Australia and also on a global scale. These
forces are driven not simply by inadequate, outmoded models of edu-
cation, but by the current hegemonic neoliberal ideology that drives
government social and economic policy,[37] with disastrous results for edu-
cation and society. Our intention is to expose and highlight how neo-
liberalism, neoconservatism and market-based ideologies, economics and
policies infuse our lives so broadly that they have become certainties and
part of the taken-for-granted nature of contemporary living—ingrained,
inevitable and rarely challenged.[38]

Armed with such power and assumed compliance, governments
forge ahead unsustainably, assuming that consumerism—where citizens
are regarded as little more than consumers making choices in a market-
place—and the commodification of everything (including education),
deregulation, privatisation and marketplace competition provide the
solutions to every problem. In this context, any unfortunate instances
of social injustice and inequality that arise are caused by the inability of
individuals and particular groups (e.g. youth, the poor, the marginalised
and disenfranchised) to adapt to the system and are not the fault of the
system itself.

In Australia and internationally, what Connell terms the *neoliberal cascade*[39] has impacted and overwhelmed all areas of life,[40] and servicing its needs and agendas become the responsibility of each citizen. Unfortunately, those who fail to succeed and slip through the net are no longer the responsibility of governments interested in the public good. Instead, the needy and marginalised, the criminals and "illegals" are turned over to business, marketised and capitalised as welfare systems are handed over to private hands. We discuss the political and policy effects in some detail in Chap. 2, but for now, it is enough to note that the responsibility for educational attainment is one that is placed on young people, and any deviation from the path is entirely the fault of the individual and not systemic and societal factors.

Of course, educational sociology has long demonstrated that factors outside of individuals' immediate control do matter when it comes to educational disadvantage. As Hayes and colleagues remind us, "schools produce unequal outcomes for students of different social and cultural backgrounds. Achievement in school is closely linked to socioeconomic background and (in Australia) command of English and Indigeneity".[41] Who you are matters when it comes to getting a start in life, and schools are often touted as being great levellers of social advantage. However, this argument does not hold up to scrutiny, as we show in Chap. 6.

Like McGregor and colleagues.[42] we feel that labelling young people as disengaged is not only inaccurate but also reframes the responsibility of education from the state to young people themselves. We agree that "a one-size-fits-all schooling model often further marginalises those students who already face significant social and economic difficulties in their everyday lives".[43] As such, the political project of our work at MIC has been to trouble the notion that there is a universal approach to schooling that will work for all young people in all places at all times. Of course, arguing for any universal cure-all is ridiculous, yet the policy machine in Australia continues to perpetuate the myth that uniformity and conformity lead to high-quality and high-equity schooling outcomes.

Underpinning the daily activities of teachers and students at MIC is a clear commitment to democratic community through a music-infused curriculum that connects to the passions and interests of the students.[44] There is no doubt that we consider MIC as a model of "goodness" in many respects. The focus on the good is not to view it or promote it so much as unique or special among schools, as though it were some kind of panacea, but to reveal how it works in a particular

context, that is how it is good for *these* students, *this* group of teachers and also *these* parents.

However, we do take this opportunity to expose not only what we consider to be good in education, but also to purposefully use MIC as a weapon[45] with which to attack the injustices prevalent in market-based education reforms and the damage done when government hands over social responsibility and the control of education to market competition and accountability mechanisms.[46] By troubling certainty, we are interested in rattling the largely unchallenged adherence to political education mantras of a "what works and is right" in education research, policy and practice. We are concerned with the profound effect these mantras have on education by contributing to social injustice and the retreat of democracy.[47]

There are dangers in blindly following improvement agendas that lack a criticality and reflexive aspect. In other words, we believe that what counts is not always able to be counted, and the focus of education systems on measuring and counting particular metrics and holding teachers and school systems accountable to those, is troubling as it leaves aside much that is important, and we will further explore these tensions throughout this book.

Finally, at the heart of this book the reader may recognise that an undercurrent is designed to consider eternal questions about the purpose of education, where a focal point has been "the struggle to combine a common goal of education with the dreams and ambitions of personal interest".[48] While we might agree that there are essential elements to a good education that are applicable to all time, the students represented in this study have been subjected to a common, standardised goal, and it evidently hasn't worked for them. Appealing to their interests, providing them with opportunities for meaningful participation, and the deep commitment to democratic principles and representation, has been a way into new possibilities and brighter futures for many marginalised young people.

This book presents a series of propositions about schooling and social justice using the stories we have generated through our connection to the MIC community. We do not attempt to make truth claims or assume that our accounts of people capture a universal truth, but are focussed on what the accounts of experience, of marginalisation, belonging and community might produce in terms of reimagining the project of schooling from a perspective of social justice. In this regard, we take up Haraway's notion of *situated knowledges*, which are "partial, locatable, critical

knowledges sustaining the possibility of webs of connections called solidarity in politics and shared conversations in epistemology".[49] We do not pretend to some removed objectivity that we are presenting without amendment, but nor do we subscribe to relativism, which is inconsistent with a critical and responsible inquiry.

Furthermore, like Hattam and colleagues, our research design does not neatly fit a particular method, as we are more interested in a *meth-odo-logic*, being the "logic of an approach for chasing socially just change through research, including guiding principles that underpin decisions and activities in all points and dimensions of the project".[50] Finally, we do not seek to simplify the complex array of lives, experiences and often contradictory ways that students and teachers take up their identities, as we agree that "the politics of simplification can be driven by efforts to forcefully translate experiences and relocate or decolonise situated knowledge".[51]

Our research plan for MIC has been to generate a detailed and dimensional illumination of the experiences and accounts of students, teachers and parents involved with the school. However, while we have asked a range of people to share their stories, we are mindful that these are snapshots in time and can only ever present some small part of the larger picture. It is not our aim to provide a definitive set of truth claims about what does or does not work in education. However, what we can say is that we are producing an account of a particular school at a specific moment in time, in order to generate further thought, discussion and questions. We consider that this kind of work is generative; it produces rather than captures, and it creates rather than records.

To do this, we have sought to explore the school from different perspectives, what Richardson describes as a process of *crystallisation*[52] through our writing. The metaphor suggests to us that looking through a crystal presents different refractions, angles and dimensions. Our use of crystallisation works in two ways: we're not only looking at the school through garnering the perspectives of different people, but are also using different philosophical, conceptual and methodological frames in order to make sense of the school in multiple ways. This is conducted not as a conceptual method for coming to any essential final conclusion, as the complexity of the issues requires a continued development of understandings that contribute, provoke and disrupt as well as enriching the discourse and dialogue. The points that we highlight are designed to

contribute to an ongoing dialogue about education, social justice and the experiences of students and teachers in schools.

Throughout this book, we make use of different narrative accounts and representations of the experiences of students, staff and parents at MIC. Our ethnographic case study framework is assembled as a qualitative research bricolage that emerged from our preparatory dialogue together. Rather than selecting a predetermined design adopted from a specific template, we reached collegial agreement to amalgamate our particular research "ways of working" and theoretical perspectives. The many similarities, including narrative approaches, make for points of reference.

Story-telling provides a compelling way of examining the different viewpoints and experiences of people, including "the unsaid, the masked, the contested, the contradictory".[53] At the same time, we are mindful that our storying of the lives of others does not simply paper over their specificities in an attempt to provide some imagined moral point or cohesive tale. To do so would be to simply colonise the voices of those who have given us access to their words and lives. The act of writing itself becomes a form of inquiry, where writing "produces meaning, creates social reality".[54]

Enamoured by the power of narrative as a mode of human meaning making, mode of cognition and way of construing reality,[55] we have individual histories of engagement with a range of theoretical aspects of narrative—as inquiry, methodology and method. In our research contexts, we collect narratives of experiences of our participants and also those of ourselves in order to honour our own subjectivities, biases, histories and to illuminate life in the research context. Included in our assemblage is a connected relationship of narrative to that of ethnographic "tale-telling" and to Van Maanen's sensitive categorisation and demarcation of academic writing into *realist, confessional* and *impressionistic* tales.[56] We use the term "data" despite its associations with supposedly impersonal hard science and matters of measurement, statistics and fact. As this doesn't sit well with our type of research, our use and meaning of data principally refers to the material of our conversations and other encounters with the lives of students, teachers and others at MIC.

Our narrative focus seeks to "illuminate" the qualities of experience. These include the understandings, the essential meanings, insights, feelings and individual ways of seeing the world. We seek to avoid an over-reliance on the distance and dispassion of *realist* (god-like, fly-on-the-wall) tales and recognise the value of more intimate, first person and

empathic inclusion of *confessional* tales and our *impressionistic* textual components show an appreciation for the value of dramatic recall, evocative language, literary devices and awareness that often "story stands alone" without the need for theoretical explanation.[57]

Vignettes are included throughout this book in order to offer background and to honour, expose and make vulnerable, self and bias in our research. We include influences from phenomenology, which helps invite and invoke a focus on the lived aspects (rather than purely theorised aspects) of experience whilst "crossing the street to the other side" to see reality from the various perspectives of the participants in our study.[58]

Our objective, when collecting, reflecting on, and synthesising data, is to honour subjectivity in order to allow participants' uniqueness and individuality to shine through. We feel that the decision to classify, codify and compartmentalise can tend to push the tenor of qualitative work into overly objectified or reified texts and the all-important returning to subjectivity keeps us in touch with the "tellers of the tale" and the ethical privileging of voice.

The remaining chapters of this book address the particular elements of MIC that we found to be of most interest in our encounters, namely the impact of policies, politics and philosophies on alternative schooling; the experiences of students who have been marginalised and disenfranchised from mainstream schooling; teachers' views on the freedoms afforded to them at MIC; the community and culture of the school and how it connects everything through music; and finally, an essay on the notion of social justice and alternative schooling, considering what affordances might be available for re-imagining education in socially just ways.

Chapter 2 expands on the philosophy of inclusive, democratic education that infuses the pedagogical landscape at MIC. It also further develops the complex policy context of alternative schooling in an era of neoliberalism, performance metrics and teacher accountability and performativity. It connects to contemporary research on global education reform and educational philosophy, in order to make a compelling case for more socially just schooling.

Chapter 3 focuses on the students at MIC, providing insights into the experiences of students who had been marginalised and disenfranchised by mainstream schooling, and who were now getting back into learning, general life motivation and in some cases, personal transformation. Comments from graduates are also included. Illustrative vignettes and comments from students provide springboards for critical highlighting

of educational matters. We deliberately include verbatim interview transcript detail (in one case, a compact and complete student story), to "give voice" to the students.

Chapter 4 addresses the experiences of the teachers who work at MIC. It breaks down the curriculum, pedagogy and assessment that underpin the daily teaching experiences in the school, as well as provides insights into the hopes and aspirations of the professional educators who form part of the school's community. Multiple vignettes are used to demonstrate approaches to curriculum and pedagogy and how these link to the importance of connectedness at MIC.

Chapter 5 takes a broader view of the school community and tracks the paths of previous students who are now "out in the world", as well as connecting with parents, school staff and other community members who have been closely integrated into the school's wider community. Key vignettes illustrate the importance of connecting to community and the development of a rich school culture, which is an essential component of socially just schooling.

Chapter 6 draws together the perspectives presented in this book and revisits the themes established in this chapter, in order to provide some salient lessons for mainstream schooling that might be re-imagined for social justice in the interests of those most disadvantaged. It shares some final thoughts that illustrate the importance of inclusive and democratic schooling for all young people and considers how the policies, philosophies and practices of MIC might be taken up and realised in other educational contexts.

NOTES

1. The actual name of the school and teachers are used with permission, while all other names, including the students, parents and former students are pseudonyms. This is in accordance both with the requirements of our university ethics clearance, as well as the wishes of the school community.

2. "I just wanted to get away from all that bullshit of territorialism and 'this is *my* space!' We avoid the silo mentality and don't even have rooms named Art, Maths, Film and TV. We've got the *Saints Room*, the *Powderfinger Room*, the *Grates Room*, the *Regurgitator Room* and the *Violent Soho* room. Each is named after a band. And that was deliberate as well because then there's no ownership over 'Well that's my room', you know", Brett, school principal.

3. At specific and strategic points, we place "autoethnographic vignettes". These are writing shifts to personal reflections that arise from our individual lived experience. These vignettes may be heartfelt and/or critical reflections, observations, confessions or impressions about the topic being discussed (these sections are placed in italics in order to clearly signify the change to a "lived experience narrative mode").
4. McGregor (2009, p. 346).
5. Riddle and Cleaver (2013).
6. Cleaver and Riddle (2014).
7. Riddle and Cleaver (2015a).
8. Riddle and Cleaver (2015b).
9. Thomson et al. (2012, p. 4) and see Riddle and Cleaver (2013).
10. Although my experience took place a long time ago, Francis and Mills (2012) when discussing violence in schools argue that with authoritarian structures of schooling young people are educated in various techniques of domination and oppression—so the trend continues.
11. An iconic music venue in Brisbane.
12. Connell (1993, p. 15).
13. Connell (1992, 1993, 2003, 2009, 2012, 2013a, 2013b).
14. Freire (1972).
15. McLaren (1995, 2007).
16. Apple (2004, 2006, 2012, 2013).
17. Giroux (1988, 1997, 2003, 2005, 2010).
18. Noddings (2003, 2013).
19. Smyth (2004, 2011, 2012).
20. Connell et al. (1982).
21. Connell (1992).
22. Thomson (2002).
23. Teese and Polesel (2003).
24. Fraser (1997, 2010).
25. Connell (1993).
26. Cleaver and Riddle (2014, p. 246).
27. Smyth (2006).
28. See Mills and McGregor (2014, p. 2).
29. Smyth, McInerney and Fish (2013, p. 299).
30. See Fielding and Moss (2011), for an examination of what they call the *dictatorship of no alternatives.*
31. See McGregor et al. (2015); McGregor et al. (2017).
32. Francis and Mills (2012).
33. McGraw (2011).

34. See Bauman (2004) for a critical analysis of humans as waste products of modernity.
35. McInerney (2012, p. 27).
36. Wrigley (2006).
37. We expand on this in some detail in Chap. 2.
38. Hursh and Henderson (2011).
39. Connell (2013b).
40. Clarke (2005), describes the pervasiveness and power of neoliberalism, stating that it does not seek "to make a model that is more adequate to the real world, but to make the real world more adequate to is model" and it has "conquered the commanding heights of global intellectual, political and economic power" in order to "subject the whole world's population to the judgment and morality of capital" (p.59).
41. Hayes et al. (2006, p. 172).
42. McGregor et al. (2017).
43. McGregor and Mills (2011, p. 18).
44. Our previous papers expand more thoroughly on these, which we won't repeat here. See Cleaver and Riddle (2014), Riddle and Cleaver (2013, 2015a, b).
45. We use the notion of weapon here in the same sense as Deleuze, (1992).
46. Davies and Bansel (2007).
47. McLaren (2007).
48. Jensen and Walker (2008, p. 122).
49. Haraway (1988, p. 584).
50. Hattam et al. (2009, p. 304).
51. Koro-Ljungberg (2012, p. 813).
52. Richardson (2000).
53. Gallagher (2011, p. 51).
54. Richardson (2001).
55. Bruner (1986).
56. Van Maanen (1988).
57. Van Maanen (1988) but see also discussion by Goodall (2000, pp. 71–72) who includes a concise description and tabled classification of the different Van Maanen "tales".
58. See van Maanen (1990, 1991) for elaboration.

REFERENCES

Apple, M.W. 2004. *Ideology and curriculum*, 3rd ed. New York: Routledge.
Apple, M.W. 2006. *Educating the "right" way: Markets, standards, god and inequality*, 2nd ed. New York: Routledge.
Apple, M.W. 2012. *Education and power*. New York, NY: Routledge.

Apple, M.W. 2013. *Can education change society?* New York, NY: Routledge.

Bauman, Z. 2004. *Wasted lives: Modernity and its outcasts.* Cambridge: Polity Press.

Bruner, J. 1986. *Actual minds, possible worlds.* Cambridge, MA: Harvard University Press.

Clarke, S. 2005. The neoliberal theory of society. In *Neoliberalism: A critical reader*, ed. A. Saad-Fihlo, and D. Johnston, 50–59. Michigan, MI: Pluto Press.

Cleaver, D., and S. Riddle. 2014. Music as engaging, educational matrix: Exploring the case of marginalised students attending an 'alternative' music industry school. *Research Studies in Music Education* 36 (2): 245–256. doi:10.1177/1321103X14556572.

Connell, R.W. 1992. Citizenship, social justice and curriculum. *International Studies in Sociology of Education* 2 (2): 133–146. doi:10.1080/0962021920020202.

Connell, R.W. 1993. *Schools and social justice.* Toronto: Our Schools Ourselves Education.

Connell, R.W. 2003. The future of public education. In *Educational imaginings: On the play of texts and contexts*, ed. J.A. Vadeboncoeur, and S. Rawolle, 335–349. Brisbane: Australian Academic Press.

Connell, R.W. 2009. Good teachers on dangerous grounds: Towards a new view of teacher quality and professionalism. *Critical Studies in Education.* 50 (3): 213–229.

Connell, R.W. 2012. Just education. *Journal of Education Policy* 27 (5): 681–683. doi:10.1080/02680939.2012.710022.

Connell, R.W. 2013a. Why do market 'reforms' persistently increase inequality? *Discourse: Studies in the Cultural Politics of Education* 34 (2): 279–285. doi:10.1080/01596306.2013.770253.

Connell, R.W. 2013b. The neoliberal cascade and education: An essay on the market agenda and its consequences. *Critical Studies in Education* 54 (2): 99–112. doi:10.1080/17508487.2013.776990.

Connell, R.W., D. Ashenden, S. Kessler, and G.W. Dowsett. 1982. *Making the difference: Schools, families and social division.* Crows Nest: Allen & Unwin.

Davies, B., and P. Bansel. 2007. Neoliberalism and education. *International Journal of Qualitative Studies in Education* 20 (3): 247–259.

Deleuze, G. 1992. Postscript on the societies of control. *October* 59, 3–7.

Fielding, M., and P. Moss. 2011. *Radical education and the common school: A democratic alternative.* Abingdon: Routledge.

Francis, B., and M. Mills. 2012. Schools as damaging organisations: Instigating a dialogue concerning alternative models of schooling. *Pedagogy, Culture & Society* 20 (2): 251–271. doi:10.1080/14681366.2012.688765.

Fraser, N. 1997. *Justice interruptus: Critical reflections on the "postsocialist" condition.* New York, NY: Routledge.

Fraser, N. 2010. *Scales of justice: Reimagining political space in a globalizing world*. New York: Columbia University Press.

Freire, P. 1972. *Pedagogy of the oppressed*. Translated by M. B. Ramos. Hammondsworth, Middlesex: Penguin Books Ltd.

Gallagher, K. 2011. In search of a theoretical basis for storytelling in education research: Story as method. *International Journal of Research & Method in Education* 34 (1): 49–61.

Giroux, H.A. 1988. *Teachers as intellectuals: Toward a critical pedagogy of learning*. Granby, MA: Bergin & Garvey.

Giroux, H.A. 1997. *Pedagogy and the politics of hope: Theory, culture and schooling*. Boulder, CO: Westview Press.

Giroux, H.A. 2003. Public pedagogy and the politics of resistance: Notes on a critical theory of educational struggle. *Educational Philosophy and Theory* 35 (1): 5–16. doi:10.1111/1469-5812.00002.

Giroux, H.A. 2005. *Border crossings: Cultural workers and the politics of education*, 2nd ed. New York, NY: Routledge.

Giroux, H.A. 2010. Rethinking education as the practice of freedom: Paulo Freire and the promise of critical pedagogy. *Policy Futures in Education* 8 (6): 715–721. doi:10.2304/pfie.2010.8.6.715.

Goodall, H. 2000. *Writing the new ethnography*. Oxford: AltaMira Press.

Haraway, D. 1988. Situated knowledges: The science question in feminism and the privilege of partial perspective. *Feminist Studies* 14 (3): 575–599.

Hattam, R., M. Brennan, L. Zipin, and B. Comber. 2009. Researching for social justice: Contextual, conceptual and methodological challenges. *Discourse: Studies in the Cultural Politics of Education* 30 (3): 303–316. doi:10.1080/01596300903037010.

Hayes, D., M. Mills, P. Christie, and B. Lingard. 2006. *Teachers and schooling making a difference: Productive Pedagogies, assessment and performance*. Crows Nest: Allen & Unwin.

Hursh, D., and J. Henderson. 2011. Contesting global neoliberalism and creating alternative futures. *Discourse: Studies in the Cultural Politics of Education* 32 (2): 171–185.

Jensen, K., and S. Walker. 2008. *Education, democracy and discourse*. Michigan, MI: Bloomsbury Academic.

Koro-Ljungberg, M. 2012. Researchers of the world, create! *Qualitative Inquiry* 18 (9): 808–818. doi:10.1177/1077800412453014.

McGraw, A. 2011. Shoving our way into young people's lives. *Teacher Development* 15 (1): 105–116.

McGregor, G. 2009. Educating for (whose) success? Schooling in an age of neo-liberalism. *British Journal of Sociology of Education* 30 (3): 345–358.

McGregor, G., and Mills, M. 2011. Teaching in alternative schools: The essence of education as the practice of freedom. Paper presented at the European Conference for Educational Research, Berlin.

McGregor, G., M. Mills, K. te Riele, and D. Hayes. 2015. Excluded from school: Getting a second chance at a 'meaningful' education. *International Journal of Inclusive Education* 19 (6): 608–625. doi:10.1080/13603116.2014.961684.

McGregor, G., M. Mills, K. te Riele, A. Baroutsis, and D. Hayes. 2017. *Re-imagining schooling for education: Socially just alternatives*. London: Palgrave MacMillan.

McInerney, P. 2012. Rediscovering discourses of social justice: Making hope practical. In *Critical Voices in Teacher Education*, ed. B. Down, and J. Smyth, 27–43. Dordrecht: Springer.

McLaren, P. 1995. *Critical pedagogy and predatory culture: Oppositional policies in a postmodern era*. London: Routledge.

McLaren, P. 2007. *Life in schools: An introduction to critical pedagogy in the foundations of education*. Boston, MA: Pearson.

Mills, M., and G. McGregor. 2014. *Re-engaging young people in education: Learning from alternative schools*. Abingdon: Routledge.

Noddings, N. 2003. Is teaching a practice? *Journal of Philosophy of Education* 37 (2): 241–251. doi:10.1111/1467-9752.00323.

Noddings, N. 2013. *Education and democracy in the 21st century*. New York: Teachers College Press.

Richardson, L. 2000. Writing: A method of inquiry. In *Handbook of qualitative research*, ed. Y. Lincoln, and N. Denzin, 923–948. Thousand Oaks, CA: Sage.

Richardson, L. 2001. Getting personal: Writing-stories. *International Journal of Qualitative Studies in Education* 14 (1): 33–38.

Riddle, S., and D. Cleaver. 2013. One school principal's journey from the mainstream to the alternative. *International Journal of Leadership in Education* 16 (3): 367–378. doi:10.1080/13603124.2012.732243.

Riddle, S., and Cleaver, D. 2015a. Speaking back to the mainstream from the margins: Lessons from one boutique senior secondary school. In *Mainstreams, margins and the spaces in-between: New possibilities for education research*, ed. K. Trimmer, A. Black and S. Riddle, 170–182. Abingdon: Routledge.

Riddle, S., and Cleaver, D. 2015b. Working within and against the grain of policy in an alternative school. *Discourse: Studies in the Cultural Politics of Education*. doi:10.1080/01596306.2015.1105790.

Smyth, J. 2004. Policy research and 'damaged teachers': Towards an epistemologically respectful paradigm. *Waikato Journal of Education* 10: 263–282.

Smyth, J. 2006. When students have power': student engagement, student voice, and the possibilities for school reform around 'dropping out' of school. *International Journal of Leadership in Education* 9 (4): 285–298. doi:10.1080/13603120600894232.

Smyth, J. 2011. *Critical pedagogy for social justice*. New York, NY: Continuum.

Smyth, J. 2012. Problematising teachers' work in dangerous times. In *Critical voices in teacher education*, ed. J. Smyth, and B. Down, 13–25. Dordrecht: Springer.

Smyth, J., P. McInerney, and T. Fish. 2013. Blurring the boundaries: From relational learning towards a critical pedagogy of engagement for disengaged disadvantaged young people. *Pedagogy, Culture & Society* 21 (2): 299–320. doi: 10.1080/14681366.2012.759136.

Teese, R., and J. Polesel. 2003. *Undemocratic schooling: Equity and quality in mass secondary education in Australia.* Carlton: Melbourne University Press.

Thomson, P. 2002. *Schooling the rustbelt kids: Making the difference in changing times.* Crows Nest: Allen & Unwin.

Thomson, P., B. Lingard, and T. Wrigley. 2012. Reimagining school change: The necessity and reasons for hope. In *Changing schools: Alternative ways to make a world of difference,* ed. T. Wrigley, P. Thomson, and B. Lingard, 1–14. London: Routledge.

Van Maanen, J. 1988. *Tales of the field: On writing ethnography.* Chicago, IL: University of Chicago Press.

Van Manen, M. 1990. *Researching lived experience: Human science for an action sensitive pedagogy.* New York, NY: State University of New York Press.

Van Manen, M. 1991. *The tact of teaching: The meaning of pedagogical thoughtfulness.* New York, NY: State University of New York Press.

Wrigley, T. 2006. *Another school is possible.* London: Bookmarks Publications.

Policies and Politics of Contemporary Schooling

The system didn't work for me. They weren't very accommodating. They just let me slip through the cracks.
Student, at a focus group interview

We have like a farewell day for the year twelves and there's a bit of live music that happens and we stand around and there's tears and hugs and all of that. One girl who'd had a very difficult life—had been fostered I think twelve times by the time we met her—she was crying and she said, "If not for here I would be dead", and she meant every word of it.
Kristin, Mathematics teacher

Abstract This chapter expands on the philosophy of inclusive, democratic education that infuses the pedagogical landscape at Music Industry College. It also further develops the complex policy context of alternative schooling in an era of neoliberalism, performance metrics and teacher accountability and performativity. It connects to contemporary research on global education reform and educational philosophy, in order to make a compelling case for more socially just schooling.

Keywords Education policy · Democratic schooling · Equity · Economic rationalism · Neoliberalism · Social justice

© The Author(s) 2017
S. Riddle and D. Cleaver, *Alternative Schooling, Social Justice and Marginalised Students*, Palgrave Studies in Alternative Education,
DOI 10.1007/978-3-319-58990-9_2

In this chapter, we explore the globalised and local policy contexts of schooling in Australia, in order to understand the milieu within which MIC exists. The first part of the chapter considers how social justice has been reframed as equity and co-opted by policy levers driven by neoliberal, neoconservative and economic rationalist ideals. We then consider how MIC walks a tight line between compliance and subversion of the policy imperatives framing schooling. We conclude the chapter with some discussion about possible implications for social justice and contemporary schooling.

The globalised context of education policy has been well covered by others,[1] and for this book, we draw on the useful notion of a *global education policy field.*[2] While we are writing a book about a particular alternative school in a local context, it is important to acknowledge how the globalised nature of education policies and politics impacts on the configuration of Australian schooling. Ball[3] argues that global policy networks result in policy flowing across the boundaries of nation states and educational sectors. What happens in the USA and the UK, in particular, influences educational developments in Australia. This is clearly demonstrated through the growing influence of neoliberalism and a resurgent neoconservative movement[4] on education policy-making and practice.

One of the most prominent examples of the global education policy field can be seen in the Programme for International Student Assessment (PISA), a triennial comparative assessment of 15-year-olds' reading, mathematics and science performance, administered by the Organisation for Economic Cooperation and Development (OECD). The resulting PISA leagues tables cause much consternation throughout the world, with *PISA shock* a common response from countries such as Australia, which continues to see a steady decline in the overall comparative performance.[5] We are not particularly interested in the interrogation of international leagues tables, which has been well covered by others.[6] What is of interest to us in this book is how the OECD explicitly compares quality and equity in educational systems. For example, in the 2012 PISA round, Australia was evaluated by the OECD as being both high quality and high equity, despite the persistent narrative of declining performance. However, this sits uncomfortably with research evidence, including the work of Teese and Polesel, which describes a much more complex picture of an educational disadvantage[7] than that offered by flattened international comparisons.

A further instance of the global education policy field comes from what Sahlberg[8] calls the *Global Education Reform Movement* (GERM), which promises improvements in quality and efficiency in education systems through standardised performance benchmarking and policy borrowing.[9] As Ball notes, "the rhetoric of reform often also manages to couple improvements in social justice and equity, of a particular kind, and the maximisation of social, educational and economic participation, to enterprise and economic success".[10] There is no doubt that within the global education policy field, "social justice and equity are being transformed through the national and global reworking of education into a field of measurement and comparison".[11] Such activities are part of a drive to reconstitute education as a primary driver of economic development and growth in a globalised market.[12] Ball[13] describes the collapsing of social and economic purposes of education into an all-consuming focus on economic competitiveness, which comes at a significant cost to the social purposes of education.

Pusey[14] labels this kind of approach as one of the *economic rationalism*, where the state—in this case, enacted through the policies of the Australian federal government—seeks to rationalise its social policy-making through a primarily economic design. This includes health, social security and education, which are all being remade through input–output driven models of efficiency and market-based mechanisms. Much of what we refer to as neoliberalism is actually a combination of classical liberal ideology—freedom of the individual rational human subject arising from the enlightenment—mixed with economic rationalism. In the age of late Capitalism, the convergence of liberalism, economic rationalism and neoconservatism provides a potent mix for schooling. And we would suggest not a healthy one at all for ensuring a quality public education system committed to principles of democratic participation and social justice.

Education has become reconstituted as a "central arm of national economic policy"[15], where equity is rearticulated as improving school performance while simultaneously bracketing out socio-economic factors.[16] In this *neosocial*[17] market of education policy, equity is reduced to an input–output model of economic productivity[18], where "equity is articulated with performance and is conceived as both the achievement of a certain level of performance and a weakening of the relationship between performance and personal, social and economic circumstances".[19] In the process, equity becomes framed as delivering efficiency and productive

outputs, where young people are supposedly given the same chances to compete in the market for employment, housing, health, and so on. This relies on economic rationalist policies, which in turn require reforming schools and other education systems.[20] As such, schooling becomes reduced to a component in the production of human capital, where global competition, efficiency and productivity are linked to the output of education[21]. There are serious implications for social justice when schooling becomes "closely hitched to the shifting imperatives of the global market".[22] As Held explains:

> Education has so far been largely out of the market, seen as a public service. But more and more schools run for profit and educational enterprises intended to reward their investors financially are being developed. The classroom is being commercialised as never before, and "privatisation," which is often corporatisation, is the predominant trend for more and more previously governmental activities. The media steadily reinforce the message that markets are better, freer, and more glamorous than any other ways of organising human life. The ideal of everyone an entrepreneur is pervasive.[23]

Further, there is an argument is that equity will be achieved, not through social democratic policies of redistribution or recognition[24] of difference approaches, but rather through a mantra of "quality, transparency and accountability".[25] Such drivers are meant to ensure that there is not only high quality but also high efficiency in the system. Of course, accountability itself is not a bad thing. However, the kinds of bureaucratic and restrictive accountabilities that are arising through the contemporary education policy landscape are at odds to the democratic accountabilities[26] that are a keystone of professional growth and community responsibility. As Biesta says:

> The predicament here is whether we are measuring and assessing what we consider valuable, or whether bureaucratic accountability systems have created a situation in which we are valuing what is being measured, i.e. a situation where measurement has become an end in itself rather than a means to achieve good education in the fullest and broadest sense of the term[27].

Furthermore, there is an increasing prevalence of standardised testing regimes and a heavy emphasis on improving teacher quality[28] as policy levers. Equity becomes framed through the notions of fairness and

inclusion,[29] where access to a consistent standard of education is guaranteed regardless of socio-economic factors. Social justice is thus marginalised in favour of advancing entrepreneurial behaviour in a competitive global economy,[30] and schooling is a central component of increasing nation states' economic productivity. Indeed, "education has been defined as an industry, and educational institutions have been forced to conduct themselves more and more like profit-seeking firms".[31]

Additionally, there has been a conflation of equity with the notion of schools as education providers in the market, offering choice and catering to the particular demands of consumers who seek to maximise return on their investment.[32] As "equity in policy is a flexible and contestable concept, capable of being rationalised in multiple ways and towards multiple ends"[33], it seems unsurprising that there would be a capturing of equity as the *tailoring* of education to meet consumer demand in the marketplace. This re-articulation of social justice as economically defined equity[34] relies on various technical and numerical mediations, representations via statistical and graphical means such as leagues tables. Like Sellar and Lingard, we are convinced that the narrowing scope of what counts as equity and social justice "must be countered by reinvigorating attention to the impact of school and social contexts on educational opportunities and outcomes".[35]

We also agree with Smyth, who argues that Australian education has been consumed by the notions of "privatisation, individualisation, competition, choice, devolution of responsibility, the user-pays ideology, and self-management".[36] There is a significant body of research[37] that demonstrates the pervasive effects of these policies on education in Australia and abroad. One effect is the ceaseless intensification of education as a site of work preparation and inflating credentialisation, which means that young people are coerced into cycles of "continuous economic capitalisation of the self".[38] The public is collapsed into the individual and the debates shift from education as a social good to one of schooling as a site of work preparation.[39] Young people become part of the *human capital*[40] that is developed for exploitation within the market.

Yet capitalism requires winners and losers, which makes for some uncomfortable tensions with an education system that seeks to uphold equity and democratic principles at its heart. Less focused on, but perhaps even more concerning, is that the youth labour market is rapidly changing, and in many places, jobs simply do not exist for graduates.[41] So the argument that schooling is inextricably linked to developing skills

for the workforce is not only reductive, but also potentially dangerous for young people who already face multiple issues of disadvantage and marginalisation. There are significant effects from the collapsing of the political into the technical, where quality, efficiency and competition are used as depoliticising tactics.[42] The *what works* mantra is a clear example of this, where efficiencies in education systems are unquestionably good and thus, whatever is going to produce the best outcomes should be accepted by all.

However, the limited view of school as a place where young people learn to become workers is deeply worrying for us, given that we see education as a social institution where "different groups with distinct political, economic, and cultural visions attempt to define what the socially legitimate means and ends of a society are to be".[43] The very question of what education is for,[44] and who gets to decide, sits at the heart of the project of contemporary schooling. Schooling is not a "passive mirror, but an active force, one that also serves to give legitimacy to economic and social forms and ideologies so intimately connected to it".[45] Nor are schools sealed units, where their outputs can be understood separate from their contexts.[46]

Bernstein describes schools as involving both an instrumental order—curriculum and knowledge transmission—and an "expressive order, which controls the transmission of the beliefs and moral system".[47] We are most interested in the notion of an expressive order, where the legitimation of particular social values is encoded into the rituals, practices and social relations of schooling as an institution. Bernstein writes extensively on ritual in education, whereby students are enculturated (not always with their consent) into the social system. Similarly, Bourdieu might consider this to be simply part of the uneven acquisition of cultural capital,[48] which is required for successful economic, political and social participation.

Thomson argues that schools are part of the policy milieu, where "whole scale economic, cultural and social changes and economic, cultural, social and even foreign policy can be seen in the day-to-day-life of schools".[49] In her book, *Other People's Children*, Delpit[50] describes how the cultural lives of marginalised and disadvantaged students are often at odds with the cultural capital expected by society.

The obsession with school reform that privileges market-based measures produces a "skewed and distorted distribution of who is able to access and benefit from education".[51] There is an inherent assumption

that all young people start from the same point in terms of access to cultural, social, economic and political capital. But we know this simply is not true. As Mills and McGregor explain, "for those young people who may lack the social and economic capital to successfully navigate a competitive society premised on 'freedom of choice', the accumulated consequences may be devastating, leaving them with little capacity to change their circumstances".[52] There are serious consequences for young people who find themselves on the margins of society, with lifelong implications for health, economic dependency, as well as capacity to engage fully in their communities.

Along with Francis and Mills, we are concerned that the quasi-marketisation of schooling and several decades of economic rationalist education policy has created an education system in Australia that "is inherently damaging: damaging both in its institutional impact on children/young people and teachers as individuals, and in its fundamental perpetuation of social inequality".[53] At its worst, schooling might be considered as a form of violence against young people,[54] including physical and psychological harm driven by "increasingly technocratic, standardised, regulated, ordered, inspected and test-driven schooling systems aimed primarily at classification and ranking".[55] Perhaps one of the most alarming aspects is in the rise of standardised testing, which Au argues[56] in his book, *Unequal by Design*, has its origins in the eugenics movement, as a function of commodifying, sorting and categorising young people. The policies of standardisation actively work towards maintaining, not removing, educational inequality.

In contrast, educational reform in Finland has considered social justice as an end in itself,[57] recognising that successful outcomes need not be motivated by a need to compete. In this instance, prioritising social justice places education out of the reach of the global race to win at all costs. Noddings comments on the state of affairs in the USA where the need to "out-innovate, out-educate and out-build the rest of the world"[58] is seen as a twenty-first-century solution to return to the greatness achieved from the twentieth-century race to the top. We agree with Keddie, who says:

A distributive understanding of justice has been the predominant focus within equity and schooling policy and practice since its inception. This focus continues to be extremely important in pursing social justice particularly given that schools continue to perpetuate class disadvantage through

the inequitable distribution of education's material benefits and given that poverty and early school leaving continue to be the most accurate predictor of educational disadvantage and future economic and social marginalisation. However, such a focus is also recognised as limited—a purely distributive approach fails to consider how matters of cultural disadvantage constrain students' educational outcomes.[59]

In Australia and elsewhere, where "neoliberal power and market-dominated society have become practical reality",[60] education goals are driven by a culture of competition which is at the heart of the ideology and discourse of government policy. The ideologically driven rationale is that we need to achieve economic success over others (we need to compete with China; we need to be top five in the world). The commodification and marketisation of everything, including education, means that schools, their students and their teachers, are bought and sold in the marketplace, and must take on mechanisms of competition. In releasing any social responsibility, such a neoliberal governmentality purports that all that is required is to create opportunity and the natural competitive spirit of citizens ensures that the rest will follow. The flawed assumption with this is that the playing field is not level at the outset. Self-interest is encouraged and social responsibility becomes further reduced.

It is unsurprising that there has been an intensification of young people disengaging from school at the same time as a "hardening of educational policy regimes that have made schools less hospitable places for students and teachers".[61] Furthermore, it seems clear to us that "the current political context in Australia is not conducive to retaining and supporting young people with complex material, social and personal needs in mainstream schools",[62] which might explain in part the enormous proliferation of alternative schooling in recent times.[63]

Australia has become a "leading celebrant of the neoliberal view of schooling"[64] over the past three decades, and this has significant implications for the lives of students and teachers working in Australian schools. Successive policy shifts have "enshrined a market-based approach to education where schools are defined as businesses and forced to compete against each other and students are defined as competitive individuals".[65] This view encourages self-interest and the rampant promotion of competition over and above a spirit of co-operation, generating inequality and a range of associated issues for students and teachers. As Connell states, "Education becomes a zone of manufactured insecurity, with

'achievement' through competition as the only remedy. But in a zero-sum competition, achievement for one means failure for all the rest".[66]

In Australia, an important policy shift occurred after the 1996 federal election of the Howard conservative coalition government, which included the disbanding of the Schools Council (itself replacing the Whitlam era Schools Commission in 1987) and shifting the emphasis from education to employment, training and youth affairs. Of particular note is the renaming of the commonwealth's Equity section as the Literacy and Numeracy section.[67] This signalled a significant change in focus from equity-based interventions such as the Disadvantaged Schools Programme[68] to an emphasis on improving literacy levels as addressing educational disadvantage. The rise of international comparative testing such as PISA, as well as national standardised testing regimes such as NAPLAN, was able to thrive in Australia as a result of this shift. Added to this has been a relatively recent move from a concern for quality teaching to an emphasis on quality teachers.

Through these policy shifts, equity in the Australian context has come to be framed in individualistic and market-based ways, where decentralisation, choice and competition[69] are expected to deliver egalitarian educational outcomes for all students. The most recent review of school funding, referred to as the *Gonski*[70] review, placed equity at the centre of its remit, claiming that "all Australian students should be allowed to achieve their very best regardless of their background or circumstances".[71] Similarly, the *Melbourne Declaration on Educational Goals for Young Australians*[72] positions access to high-quality schooling and educational equity at the heart of its policy imperative, claiming that "as well as knowledge and skills, a school's legacy to young people should include national values of democracy, equity and justice".

However, as Mills and McGregor argue, the Melbourne Declaration also "established a policy framework of intent that reflected global education trends and promised to raise the competitive edge of Australia's results from international tests",[73] buying into the argument of education as a tool for economic development. While these notions of equity might appear to be uncontroversial, whether related specifically to schools funding or more generally to the goals of education, the question is more about how they play out in the policy arena. For example, the ongoing controversy surrounding the Gonski report clearly demonstrates that the question of what counts in schooling and who should pay

for what, the very notion of a public education, and so on, are far from settled.

We find it of significant concern that the "option" of alternative schooling means that public schools are given the opportunity to abrogate their responsibility to educate all students, regardless of their backgrounds and needs. So, in this regard, we are very aware of the dangerous road that a simple exaltation of successful alternative schooling (like MIC) might become. Rather, we consider our work to fit within a broader project that might be described as a struggle to reconstitute and re-imagine mainstream schooling in counter-hegemonic ways that work in the interests of those who are least advantaged by the system.[74] We would prefer a schooling system where MIC did not have to exist, because the students who have found themselves there never needed to look for an alternative in the first place.

What interests us most about MIC is how it operates as a *socially just school*,[75] rather than how it operates as an alternative school. Smyth and colleagues describe the hallmarks of a socially just school as starting from a primary commitment to engage with young people from where they are, not from where schools or governments wish them to be. For us, this is an important difference from schooling-as-usual, as it means that all young people are "entitled to an educationally rewarding and satisfying experience of school – not only those whose backgrounds happen to fit with the values of schools".[76] We are also interested in listening to young people and treating them as being "at promise" rather than "at risk". This fits with the leadership style of the school principal, Brett,[77] who made the following comments in relation to mainstream schooling in Australia:

> We ask kids to comply and if they don't they're the problem so we sack them, and I genuinely don't believe there's any such thing as a bad kid, they're just good kids in bad situations.

Also of interest to us are the ways in which MIC is able to "work within and against the grain of policy simultaneously".[78] In other words, how does the school manage to jump through all the hoops required for regulatory authorities, while also ensuring that the diverse needs of students are addressed through the curriculum, pedagogy and school culture? We have written about this in some detail previously,[79] although what is important here is the claim that situated, meaningful and contextualised

curriculum, pedagogical and relational work can be done in schools like MIC, which work in some way to alleviating the effects of disadvantage and marginalisation that young people face. However, like Hayes and colleagues[80] are careful to establish, we feel that schooling can make *some* but not *all* of the difference to the lives of young people.

We are also interested in the notion of what makes for a *meaning-ful* education, understanding that the term is a contested one, given to subjective difference and personal accounts. McGregor and colleagues describe a meaningful education as the building of bridges between "personal contexts and needs and a desired future".[81] Perhaps more significantly for the students who find themselves at MIC, a meaningful education is one that will "resonate with the needs and aspirations of young people who find themselves on the outside of mainstream schooling pathways".[82] Our project has demonstrated that commitment, community and culture and curriculum connectedness[83] are the important factors for reconnecting young people to schooling in meaningful ways. We also recognise there is a clear need to deliberately blur the boundaries between the political, philosophical and personal[84] in order to understand the complex interplay of the experiences of students and teachers that exist within school communities.

Our purpose in this book is to critically hold the philosophy and practice of MIC up against current trends in educational policy, politics and ideology, and we illuminate how the positive climate of culture and community, together with the connectedness of the curriculum, offer a particular example of participatory democracy-in-action. We engage with the topic of democratic community recognising that many ingredients at MIC meld together as components of a just system deliberately put into place through careful governance and the purposeful intentions of Brett[85] through his leadership and vision for the school.

These intentions resonate with Apple and Beane, who explain how "democratic schools, like democracy itself, do not happen by chance. They result from explicit attempts by educators to put in place arrangements and opportunities that will bring democracy to life".[86] From collected narratives of experience, we learn how the curriculum content, which is purposefully adapted to the needs and interests of the students, the positive social and mutually respectful relationships, and the cohesive culture at MIC, all work harmoniously together to create a democratic community that works for the good of the collective social life and

for each individual student and teacher. The concepts of democracy and social justice are mutual in that:

> Each holds within itself the notion of both individual rights and the good of the community. While justice is often related to individual rights, it is tempered by the term "social"; while democracy is often related to the protection of individual rights, community reminds us that individual rights are bounded by concerns about ways in which we must live together in society.[87]

From our perspective, social justice and democratic community form a core of the moral purpose of schools and "deeply democratic communities focus on how people live, work, and interact, how they develop relationships and learn together in these relationships".[88] This comment is poignant and contrasts with school structures based on a lack of trust, separateness and an "us against them" mentality, where teachers teach and students learn, and forms of authority that demand rigid impersonal relationships. The current rise of no-excuses and zero-tolerance school behaviour policies in places like the UK are a trend that we would hope to not see in Australia.

As Giroux[89] argues, it is not enough for knowledge and habits of good citizenship to be taught, but a deep engagement with critical citizenship should be at the heart of schools as democratic public spaces. The depoliticising effects of contemporary market-based education policy actively work to undermine democratic approaches through reframing the social and the political as purely economic.[90] We wish to work against such undermining by viewing schooling, and in this book the example of MIC, as democratic public spheres. McLaren argues that if we are to view schools as democratic public spheres, they need to engage students in "meaningful dialogue and action and to give students the opportunity to learn the language of social responsibility".[91] He continues, to say that a democratic commitment involves a "fundamental respect for individual freedom and social justice". It seems clear to us that a commitment to both social justice and democratic participation is a necessary pre-condition for reconfiguring schooling in ways that run counter to the current reform agenda.

In acknowledging both the rights of the individual and the good of the community, a democratic education will effect societal and personal transformation. Importantly, the type of personal transformation

we witness at MIC is where the students are empowered as the agents of their own change.[92] This is unlike many dominant and authoritarian education contexts where the power relations control and manipulate the direction and "becoming" of the student for the purpose of social control, for religious, ideological or moral persuasion, or where curriculum is tightly controlled in order to serve the economic needs of the state and when "educating for human capital".[93] In contrast, we found many narratives of personal agency, empowerment and transformation through the MIC experience.

In observations from initial research, we had described how the students and teachers at MIC have "opportunities to speak to power, reframing the school's institutional discourses and working continually towards an ethic of social justice and care".[94] The democratic and respectful treatment of young people at MIC creates an environment of acceptance for diversity and for different types of learners. As one example of many, the following extract is from an interview with Jeremy, a Year 11 student:

Could you tell us about your first six months here? What has happened for you? Perhaps you can compare it with the other types of schooling that you've done and what has happened for you since you've been here?

Well they've been really welcoming. I have Asperger Autism and I'm not as sociable as most people here so I think people have been more...they haven't exactly noticed that I've got that thing that's holding me back a bit and so it's been really nice having that. They don't mention it. I'm treated like the rest of the class, where at my old school it was very much, "Jeremy, do this!", and then the rest would do another thing. They would single me out a lot.

So were you comfortable at your last school?

No.

Similarly, when Trey spoke with us about her arrival at MIC, she said:

It's a very, very welcoming community. Straight off the bat we go on an orientation week camp. So before we even go to school we all get sent off to the Sunshine Coast for three days together to get to know each other, and then on the next week when we start classes we have some friendships. So it was very welcoming, very easy to get to know people. Even if you

didn't do the same genre or the same singing voice as someone else, every-
one was still really supportive. And we had an Open Mic session on camp,
so you just sign up and go for it. And hearing like that diversity of music
and the range of voices and the different things, it's amazing. And you can
pick out the people that, "I want to collaborate with her" or "I want him
to play guitar for me", and through that you go up and you would say
that, and it's just instant friendship.

At MIC, a climate freed from the need to compare and compete contrib-
utes to the positive school community vibe. In place of competition, a
spirit of co-operation is fostered. This goes against the grain of the neo-
liberal agenda and indeed against a broadly accepted, traditional reliance
on competition as a coercive motivator in many mainstream schooling
contexts. Many of the MIC students report thriving in the spirit of co-
operation and appreciate not being forced to compete with each other.

As we described in Chap. 1, the range of identities, personalities and
backgrounds are varied and complex but at MIC, Emo, Heavy Metal,
Goth and Nerd[95] co-operate and exist collaboratively, and we appreciate
that in many individual stories, our young participants have railed against
being forced into competitive modes of being. We find it particularly
poignant that this group of young people readily choose modes of co-
operation while rejecting earlier school training in compliance with the
world of competition.

The school is accredited through the Queensland Curriculum
and Assessment Authority (QCAA), which oversees the credential-
ing of school systems and senior certification in the state. The school is
required to undertake regular accreditation reviews as an independent
school, demonstrating that its curriculum aligns with state-mandated
syllabuses. Financial audits and curriculum reviews are a requirement
in order to keep the doors open. The governance structure includes a
school board, to whom the principal, Brett, reports on compliance, pol-
icy and other governance matters. Thomson[96] argues that school prin-
cipals are policy mediators who are active agents engaging in dynamic,
tactical practices that cross the political and policy landscapes into educa-
tional contexts. Our previous commentary on Brett's leadership and the
school's policy tightrope walking bears this out.[97]

Perhaps the most important thing that we take from the ways that
teachers and students work at MIC within the policy and political land-
scape of schooling is that they manage to both work within and against

the grain of policy. In other words, what needs to be done (in the sense of being accredited as a school, credentialing graduates with a high school diploma, and so on) is managed, while what really needs to be done (the relational and affective work of building a rich learning community, as well as the commitment to democratic civic life within and beyond the school) is foregrounded.

We believe that the pursuit of social justice cannot be an empty one, and given the current context of contemporary schooling, a project that requires dedicated and unwavering commitment. As Connell argues, "social justice requires moving out from the starting-point to *reconstruct the mainstream* to embody the interests of the least advantaged in a generalised way".[98] It is not enough that schools like MIC can exist, although we are very glad that they do give the current policy and political climate, but something needs to change with schooling more broadly. From our perspective, it is this argument of reconstituting the mainstream that drives our work with MIC and other places. And this why the following chapters deal directly with the experiences of teachers and students, plus the school community more broadly, in order to understand some of the ways that they navigate their experiences at MIC. In doing so, we hope to illuminate some possible avenues for a hopeful reconstruction of schooling.

NOTES

1. For example, see: Ball (2012, 2016), Biesta (2010), Lingard and Sellar (2013), Lingard et al. (2014), Rizvi and Lingard (2010), Rose (1999).
2. Lingard and Rawolle (2011).
3. Ball (2016).
4. For a full critique of neoliberal/neoconservative modernism and education, see: Apple (2004, 2006, 2013, 2014).
5. For a starting point on the media-focused discussion on PISA, see: Riddle and Lingard (2016), Riddle et al. (2013).
6. See: Lingard and Sellar (2013), Lingard et al. (2014).
7. Teese and Polesel (2003).
8. Sahlberg (2006).
9. The distinction between policy borrowing and policy learning is well made by Lingard (2010).
10. Ball (2008, p. 17).
11. Lingard et al. (2014, p. 711).
12. Sahlberg (2006).

13. Ball (2008, pp. 11–12).
14. Pusey (1991).
15. Rizvi and Lingard (2010, p. 96).
16. Sellar and Lingard (2014).
17. Rose (1999).
18. Savage (2013).
19. Sellar and Lingard (2014, p. 2).
20. McInerney and Smyth (2014, p. 241).
21. Down (2009).
22. Down (2009, p. 52).
23. Held (2006, p. 112).
24. These policies draw in some part on Nancy Fraser's (1997, 2010) notions of justice as having elements of redistribution (economic), recognition (cultural) and representation (political). Many of the previous equity programmes were heavily invested in a politics of redistribution, or what is commonly known as compensatory education.
25. Kenway (2013, p. 287).
26. Biesta (2015).
27. Biesta (2015, p. 83).
28. Lingard et al. (2014).
29. Sellar and Lingard (2014).
30. Liasidou and Symeou (2016).
31. Connell (2013b, p. 102).
32. We expand on this issue at some length in Chap. 6.
33. Savage (2013, p. 188).
34. Lingard et al. (2014, p. 711).
35. Sellar and Lingard (2014, p. 4).
36. Smyth (2016, p. 314).
37. For example, see: Apple (2004, 2006, 2013), Connell (2013a, b), Davies and Bansel (2007), McGregor (2009), Olssen and Peters (2005).
38. Rose (1999, p. 161).
39. Ball (2008, p. 189).
40. For a useful discussion on schooling and human capital, see: McGregor et al. (2017).
41. Down (2009).
42. Clarke (2012).
43. Apple (1993, p. 49).
44. Biesta (2015).
45. Apple (2004, p. 39).
46. Connell et al. (1982).
47. Bernstein (2003, p. 49).
48. Bourdieu (1991), Bourdieu and Passeron (1990).

49. Thomson (2002, p. 181).
50. Delpit (2006).
51. Smyth et al. (2014, p. 4).
52. Mills and McGregor (2014, p. 16).
53. Francis and Mills (2012, p. 252).
54. For a highly detailed and sobering account of schools as damaging, violent institutions, see: Harber (2004).
55. Harber (2002, p. 14).
56. Au (2009).
57. Sahlberg (2011). See also Connell (1993).
58. Noddings (2013, p. 2). The strong warning is given not to repeat the horrors.
59. Keddie (2012, p. 267).
60. Connell and Dados (2014).
61. Smyth (2006, p. 279).
62. McGregor et al. (2015, p. 609).
63. te Riele (2007).
64. Smyth (2016, p. 307).
65. Smyth et al. (2014, p. 139).
66. Connell (2012, p. 681). Also see discussion from Smyth et al. (2014, p. 139).
67. Henry (2001).
68. Connell et al. (1982).
69. Henry (2001).
70. Named for the chair of the expert review panel, David Gonski, a prominent Australian business leader. The *Review of Funding for Schooling* was commissioned by the Federal Labor government in 2010 and has caused much subsequent controversy.
71. Gonski et al. (2011, p. 29).
72. MCEETYA (2008, p. 5).
73. Mills and McGregor (2016, p. 116).
74. Connell (1993).
75. Smyth (2016), Smyth et al. (2014).
76. Smyth et al. (2014, p. 3).
77. For a more detailed account of Brett's leadership, see: Riddle and Cleaver (2013).
78. Thomson et al. (2012, p. 4).
79. Riddle and Cleaver (2015a).
80. Hayes et al. (2006).
81. McGregor et al. (2015, p. 613).
82. McGregor et al. (2015, p. 611).
83. See Riddle and Cleaver (2013, 2015a).

84. Smyth et al. (2013).
85. See Riddle and Cleaver (2013) for detail of Brett's intentions for a democratic community at MIC.
86. Apple and Beane (1999, p. 10). See also Furman and Shields (2005) for further discussion on democratic schooling.
87. Furman and Shields (2005, p. 126).
88. Furman and Shields (2005, p. 133).
89. Giroux (2005).
90. Clarke (2012).
91. McLaren (2007, p. 253).
92. We unpack these in some detail in Chap. 3.
93. See discussion, Apple (2006, p. 32).
94. Riddle and Cleaver (2013, p. 374).
95. These are terribly clichéd subcultural labels, but we use them here to make the point that diversity and difference are strengths of the school community.
96. Thomson (2002).
97. See Riddle and Cleaver (2013, 2015b).
98. Connell (1992, p. 139).

References

Apple, M.W. 1993. Thinking 'right' in the USA: Ideological transformations in an age of conservatism. In *Schooling reform in hard times*, ed. B. Lingard, J. Knight, and P. Porter, 49–62. London: The Falmer Press.

Apple, M.W. 2004. *Ideology and curriculum*, 3rd ed. New York: Routledge.

Apple, M.W. 2006. *Educating the "right" way: Markets, standards, god and inequality*, 2nd ed. New York: Routledge.

Apple, M.W. 2013. *Can education change society?* New York: Routledge.

Apple, M.W. 2014. *Official knowledge: Democratic education in a conservative age*, 3rd ed. New York: Routledge.

Apple, M.W., and J.A. Beane. 1999. *Democratic schools: Lessons from the chalk face*. Buckingham: Open University Press.

Au, W. 2009. *Unequal by design: High-stakes testing and the standardisation of inequality*. New York: Routledge.

Ball, S.J. 2008. *The education debate*. Bristol: Policy Press.

Ball, S.J. 2012. *Global education Inc: New policy networks and the neo-liberal imaginary*. London: Routledge.

Ball, S.J. 2016. Following policy: Networks, network ethnography and education policy mobilities. *Journal of Education Policy* 31 (5): 549–566. doi:10.1080/02680939.2015.1122232.

Bernstein, B. 2003. *Class, codes and control volume III: Towards a theory of educational transmission.* London: Routledge.

Biesta, G. 2010. *Good education in age of measurement: Ethics, politics, democracy.* Boulder, CO: Paradigm.

Biesta, G. 2015. What is education for? On good education, teacher judgement and educational professionalism. *European Journal of Education* 50 (1): 75–87. doi:10.1111/ejed.12109.

Bourdieu, P. 1991. *Language and symbolic power*, trans. and G. Raymond and M. Adamson. Cambridge: Polity Press.

Bourdieu, P., and J.C. Passeron. 1990. *Reproduction in education, society and culture*, trans. R. Nice. London: Sage.

Clarke, M. 2012. The (absent) politics of neo-liberal education policy. *Critical Studies in Education* 53 (3): 297–310. doi:10.1080/17508487.2012.703139.

Connell, R.W. 1992. Citizenship, social justice and curriculum. *International Studies in Sociology of Education* 2 (2): 133–146. doi:10.1080/0962021920020202.

Connell, R.W. 1993. *Schools and social justice.* Toronto: Our Schools Ourselves Education.

Connell, R.W. 2012. Just education. *Journal of Education Policy* 27 (5): 681–683. doi:10.1080/02680939.2012.710022.

Connell, R.W. 2013a. Why do market 'reforms' persistently increase inequality? *Discourse: Studies in the Cultural Politics of Education* 34 (2): 279–285. doi:10.1080/01596306.2013.770253.

Connell, R.W. 2013b. The neoliberal cascade and education: An essay on the market agenda and its consequences. *Critical Studies in Education* 54 (2): 99–112. doi:10.1080/17508487.2013.776990.

Connell, R.W., and N. Dados. 2014. Where in the world does neoliberalism come from? The market agenda in southern perspective. *Theory and Society* 43 (2): 117–138. doi:10.1007/s11186-014-9212-9.

Connell, R.W., D. Ashenden, S. Kessler, and G.W. Dowsett. 1982. *Making the difference: Schools, families and social division.* Crows Nest: Allen & Unwin.

Davies, B., and P. Bansel. 2007. Neoliberalism and education. *International Journal of Qualitative Studies in Education* 20 (3): 247–259.

Delpit, L. 2006. *Other people's children: Cultural conflict in the classroom.* New York: The New Press.

Down, B. 2009. Schooling, productivity and the enterprising self: Beyond market values. *Critical Studies in Education* 50 (1): 51–64. doi:10.1080/17508480802526652.

Francis, B., and M. Mills. 2012. Schools as damaging organisations: Instigating a dialogue concerning alternative models of schooling. *Pedagogy, Culture & Society* 20 (2): 251–271. doi:10.1080/14681366.2012.688765.

Fraser, N. 1997. *Justice interruptus: Critical reflections on the "postsocialist" condition*. New York: Routledge.

Fraser, N. 2010. *Scales of justice: Reimagining political space in a globalizing world*. New York: Columbia University Press.

Furman, G., and C. Shields. 2005. How can educational leaders promote and support social justice and democratic community in schools? In *A new agenda for research in educational leadership*, ed. W. Firestone and C. Riehl, 119–137. New York: Teachers College Press.

Giroux, H.A. 2005. *Border crossings: Cultural workers and the politics of education*, 2nd ed. New York: Routledge.

Gonski, D., K. Boston, K. Greiner, C. Lawrence, B. Scales, and P. Tannock. 2011. *Review of funding for schooling: Final report*. Canberra: Department of Education, Employment and Workplace Relations.

Harber, C. 2002. Schooling as violence: An exploratory overview. *Educational Review* 54 (1): 7–16. doi:10.1080/00131910120110839.

Harber, C. 2004. *Schooling as violence: How schools harm pupils and societies*. Abingdon: RoutledgeFalmer.

Hayes, D., M. Mills, P. Christie, and B. Lingard. 2006. *Teachers and schooling making a difference: Productive Pedagogies, assessment and performance*. Crows Nest: Allen & Unwin.

Held, V. 2006. *The ethics of care: Personal, political, and global*. Oxford: Oxford University Press.

Henry, M. 2001. *Policy approaches to educational disadvantage and equity in Australian schooling*. Paris: UNESCO.

Keddie, A. 2012. Schooling and social justice through the lenses of Nancy Fraser. *Critical Studies in Education* 53 (3): 263–279. doi:10.1080/17508487.2012.709185.

Kenway, J. 2013. Challenging inequality in Australian schools: Gonski and beyond. *Discourse: Studies in the Cultural Politics of Education* 34 (2): 286–308. doi:10.1080/01596306.2013.770254.

Liasidou, A., and Symeou, L. (2016). Neoliberal versus social justice reforms in education policy and practice: Discourses, politics and disability rights in education. *Critical Studies in Education*, 1–18. doi:10.1080/17508487.2016.1186102.

Lingard, B. 2010. Policy borrowing, policy learning: Testing times in Australian schooling. *Critical Studies in Education* 51 (2): 129–147. doi:10.1080/17508481003731026.

Lingard, B., and S. Rawolle. 2011. New scalar politics: Implications for education policy. *Comparative Education* 47 (4): 1–18.

Lingard, B., and S. Sellar. 2013. Globalisation and sociology of education policy: The case of PISA. In *Contemporary debates in the sociology of education*,

ed. R. Brooks, M. McCormack, and K. Bhopal, 39–56. Basingstoke: Palgrave Macmillan.

Lingard, B., S. Sellar, and G. Savage. 2014. Rearticulating social justice as equity in schooling policy: The effects of testing and data infrastructures. *British Journal of Sociology of Education* 35 (5): 710–730. doi:10.1080/01425692. 2014.919846.

MCEETYA. 2008. *Melbourne declaration on educational goals for young Australians.* Melbourne: Ministerial Council on Education, Employment, Training and Youth Affairs.

McGregor, G. 2009. Educating for (whose) success? Schooling in an age of neo-liberalism. *British Journal of Sociology of Education* 30 (3): 345–358.

McGregor, G., M. Mills, K. te Riele, and D. Hayes. 2015. Excluded from school: Getting a second chance at a 'meaningful' education. *International Journal of Inclusive Education* 19 (6): 608–625. doi:10.1080/13603116.2014.961684.

McInerney, P., and J. Smyth. 2014. 'I want to get a piece of paper that says I can do stuff': Youth narratives of educational opportunities and constraints in low socio-economic neighbourhoods. *Ethnography and Education* 9 (3): 239–252. doi:10.1080/17457823.2013.873349.

McLaren, P. 2007. *Life in schools: An introduction to critical pedagogy in the foundations of education.* Boston, MA: Pearson.

Mills, M., and G. McGregor. 2014. *Re-engaging young people in education: Learning from alternative schools.* Abingdon: Routledge.

Mills, M., and G. McGregor. 2016. Learning not borrowing from the Queensland education system: Lessons on curricular, pedagogical and assessment reform. *The Curriculum Journal* 27 (1): 113–133. doi:10.1080/09585 176.2016.1147969.

Noddings, N. 2013. *Education and democracy in the 21st century.* New York: Teachers College Press.

Olssen, M., and M.A. Peters. 2005. Neoliberalism, higher education and the knowledge economy: From the free market to knowledge capitalism. *Journal of Education Policy* 20 (3): 313–345.

Pusey, M. 1991. *Economic rationalism in Canberra: A nation-building state changes its mind.* Cambridge: Cambridge University Press.

Riddle, S., and D. Cleaver. 2013. One school principal's journey from the mainstream to the alternative. *International Journal of Leadership in Education* 16 (3): 367–378. doi:10.1080/13603124.2012.732243.

Riddle, S., and D. Cleaver. 2015a. Speaking back to the mainstream from the margins: Lessons from one boutique senior secondary school. In *Mainstreams, margins and the spaces in-between: New possibilities for education research,* ed. K. Trimmer, A. Black, and S. Riddle, 170–182. Abingdon: Routledge.

Riddle, S., and D. Cleaver. 2015b. Working within and against the grain of policy in an alternative school. *Discourse: Studies in the Cultural Politics of Education.* doi:10.1080/01596306.2015.1105790.

Riddle, S., and B. Lingard. 2016. PISA results don't look good, but before we panic let's look at what we can learn from the latest test. *The Conversation.* Accessed from https://theconversation.com/pisa-results-dont-look-good-but-before-we-panic-lets-look-at-what-we-can-learn-from-the-latest-test-69470.

Riddle, S., B. Lingard, and S. Sellar. 2013. Australia's PISA slump is big news but what's the real story? *The Conversation.* Accessed from https://theconversation.com/australias-pisa-slump-is-big-news-but-whats-the-real-story-20964.

Rizvi, F., and B. Lingard. 2010. *Globalizing education policy.* New York: Routledge.

Rose, N. 1999. *Powers of freedom: Reframing political thought.* Cambridge: Cambridge University Press.

Sahlberg, P. 2006. Education reform for raising economic competitiveness. *Journal of Educational Change* 7 (4): 259–287. doi:10.1007/s10833-005-4884-6.

Sahlberg, P. 2011. *Finnish lessons: What the world can learn from educational change in Finland.* New York: Teachers College Press.

Savage, G. 2013. Tailored equities in the education market: Flexible policies and practices. *Discourse: Studies in the Cultural Politics of Education* 34 (2): 185–201. doi:10.1080/01596306.2013.770246.

Sellar, S., and B. Lingard. 2014. Equity in Australian schooling: The absent presence of socioeconomic context. In *Contemporary issues of equity in education*, ed. S. Gannon and W. Sawyer, 1–21. Newcastle upon Tyne: Cambridge Scholars Publishing.

Smyth, J. 2006. Educational leadership that fosters 'student voice'. *International Journal of Leadership in Education* 9 (4): 279–284. doi:10.1080/13603120600894216.

Smyth, J. 2016. The Australian case of education for citizenship and social justice. In *The Palgrave international handbook of education for citizenship and social justice*, ed. A. Peterson, R. Hattam, M. Zembylas, and J. Arthur, 307–325. London: Palgrave Macmillan UK.

Smyth, J., P. McInerney, and T. Fish. 2013. Blurring the boundaries: From relational learning towards a critical pedagogy of engagement for disengaged disadvantaged young people. *Pedagogy, Culture & Society* 21 (2): 299–320. doi: 10.1080/14681366.2012.759136.

Smyth, J., B. Down, and P. McInerney. 2014. *The socially just school: Making space for youth to speak back.* Dordrecht: Springer.

te Riele, K. 2007. Educational alternatives for marginalised youth. *The Australian Educational Researcher* 34 (3): 53–68. doi:10.1007/ BF03216865.

Teese, R., and J. Polesel. 2003. *Undemocratic schooling: Equity and quality in mass secondary education in Australia*. Carlton: Melbourne University Press.

Thomson, P. 2002. *Schooling the rustbelt kids: Making the difference in changing times*. Crows Nest: Allen & Unwin.

Thomson, P., B. Lingard, and T. Wrigley. 2012. Reimagining school change: The necessity and reasons for hope. In *Changing schools: Alternative ways to make a world of difference*, ed. T. Wrigley, P. Thomson, and B. Lingard, 1–14. London: Routledge.

Finding Myself at Music Industry College

I was at my last private school until the start of grade ten where I had some problems just with issues and stuff. So it didn't really work out, and I just dropped out. I spent a year not doing anything. I went through a couple of mental health wards and stuff, just with depression daily and that sort of thing, and then at the end of last year I found this place and so I decided to come here. It is more relaxed and it suits me.
Alfred, student

Abstract This chapter focuses on the students at Music Industry College, providing insights into the experiences of students who had been marginalised and disenfranchised by mainstream schooling, and who were now getting back into learning, general life motivation and in some cases, personal transformation. Comments from graduates are also included. Illustrative vignettes and comments from students provide springboards for critical highlighting of educational matters.

Keywords Students · Relational · Disenfranchised · Marginalised
Young people · Social justice

In this chapter, we present the experiences and perspectives of students at MIC, about how they came to the school, what it means for them,

© The Author(s) 2017
S. Riddle and D. Cleaver, *Alternative Schooling, Social Justice and Marginalised Students*, Palgrave Studies in Alternative Education,
DOI 10.1007/978-3-319-58990-9_3

and how they have changed as a result. We hear of life before MIC, with a variety of mainstream school experiences and reasons given for being excluded, marginalised and disenfranchised. We were interested to discover student perceptions of how they didn't fit into the mainstream and to give voice to issues and concerns about their lives in school. We hear about their re-engagement in learning and the relaying of hopes and aspirations. Varied accounts reveal whether it was the previous school that rejected the student or if it was the student who rejected the school. Stories of "life after MIC" provide further dimensions about the school and we also share some of the reflections and lessons that have been learnt through young people reconnecting to schooling.

It is important to state, in order to avoid what might appear as a hagiographic stance, that we do recognise the competing discourses of youth-at-risk and learning choices, which operate in discussions of alternative versus mainstream schooling.[1] While we do not subscribe to a deficit view of students, where it is assumed that they need "fixing", we are concerned that a simple "fix the school" approach might be similarly unhelpful. We do recognise how unfortunate it is that, "the perspective, lives and aspirations of the people who are supposed to be the beneficiaries of education policies are still largely absent when it comes to informing curriculum guidelines and school practices".[2] As McLaren argues,[3] an engaged and critical pedagogy should take the needs and problems of students themselves as a starting point. Hence, we recognise that it is important to talk with students in order that their voices can be included in decision-making processes.[4] Therefore, in this chapter we examine what the particular experiences of students at MIC might have to teach us.

Importantly, as we explore more fully in Chap. 5, the principles of democratic education and active citizenship are heavily invested in an understanding of schooling and social justice. Guiding our exploration of how MIC contributes to the well-being and personal lives of students, our reference about citizenship and social justice is guided by Smyth, who advises us to understand:

> the way schools choose to structure the educational lives of young people, the way they treat them as citizens, the respect they accord to their familial, cultural, racial, class, sexualized and gendered backgrounds, and the kind of opportunity structures schools construct for young people.[5]

Observing from the perspectives of students allows us to continue to wedge ideas into competing political discourses about education and social justice and democratic approaches to schooling. Again, with no easy fix, we are aware that, "amid the unprecedented and rising levels of ethnic, racial, religious and class diversity within western classrooms, engaging with the politics of student difference has never been more difficult and contentious".[6] Against this backdrop, both students and their teachers are confronted by a problematic incongruity, or double standard that wrenches, pulls and twists at them from opposite sides. On the one hand, the concept of diversity and understanding learner diversity in teacher education is a matter isolated for serious study[7] and on the other hand, diversity is seemingly nullified through mandated regimes of standardisation and "one size fits all" curriculum. An unfortunate outcome is that, "rather than valorising learner diversity as a positive aspect of educational experience, learner diversity is regarded as being a major threat to standardised performance indicators".[8] We consider MIC to be a good example of a community where diversity and difference are treated as strengths, rather than a problem to be addressed.

We are cautious of consulting with students and then presenting their perspectives for purposes other than giving them voice and to speak defensively for them against the neoliberal cascade of social injustice where they are predominantly shoved around[9] and shaped as human capital for the private sector.[10] Unfortunately, student voice is often used under the guise of being democratic and helpfully consultative. Mockler and Groundwater-Smith provide a description of how student voice is used not for the students' benefit but for marketing purposes and the feeding of instrumentalist agendas. They describe how this is also occurring in the university sector, claiming:

> The rise of audit cultures in universities, closely linked to the commodification of higher education and the positioning of students as 'consumers' of a product, has led to a widespread adoption of 'student voice' as a marketing tool. In situations such as this, it could be argued that feedback from students is wielded as something of a blunt instrument and used in a purely transactional manner, generally not reaching what we would consider to constitute authentic engagement.[11]

Following this description of inauthenticity, we are mindful that the use of student voice as a blunt instrument is in reality, an agenda hidden

deceptively from any socially just purpose. At the same time, we are cautious not to oversubscribe to an emancipatory politics of student voice, as we do not consider ourselves missionary types, come to save young people from their plights through allowing them to speak. Often this results in little more than the capturing and presentation of other's experiences, hopes and fears, for the researchers' own purposes. What we hope to do in this book is to present the stories that MIC students shared with us, as part of the argument for a more socially just schooling that serves the interests of those who are excluded and marginalised from the current system.

What is a school if it does not serve the best interests of those being taught? When schools continue to ignore the interests of students, while focusing on instrumentalist agendas, students can become unmotivated, and the exploitation negatively impacts on their lives. Smyth describes young people switching off and dropping out of school in detail:

> When students feel their lives, experiences, cultures and aspirations are ignored, trivialised, or denigrated by school and the curriculum, they develop a hostility to the institution of schooling. They feel that schooling is simply not worth the emotional and psychological investment necessary to warrant their serious involvement.[12]

When we serve up education to the young with hidden agendas about its purposes, we shamelessly model inauthenticity. Criticality is directed away from what is real and it then becomes normal to deceive, which we argue produces things such as fake news, alternative facts and President Trump.[13] This was commonplace in the old industrial model of education, where it was assumed that children didn't need to know what and why they were being taught and education was simply *done to them*. As a general comment, young people today are informed at earlier ages and stages and become self-interested and aware enough to know if they are being taught for a different purpose other than that openly stated.

Importantly, at MIC students are guided specifically as to why they are there, are asked to reflect and are presented with no illusions about the realities of preparing to survive in the world of the music industry— not everyone is going to be a rock star, a famous record producer or an entrepreneurial music promoter. In most cases, this reality is faced squarely and MIC students either increase their commitment to a chosen

path of interest and passion or seem happy to review their options while being open to new possibilities. Serena, the maths teacher, discussed with us the need for talking openly with students about the realities of purpose, reasons for being at MIC, what it is that the students want and the chances of making it big in the music scene. This opens them to realism but also to potential in other fields and it assists them in making responsible decisions about their own path:

> Brett often plays 'It's a Long Way to the Top (If You Want to Rock 'n Roll)' to the kids. He doesn't build any false hope, that's for sure, and for things like sound engineering, it's a very popular thing our kids want to get into, but he is very honest about how few jobs there are in that industry. But he also, if there is a shot or an opportunity, he connects people. He networks for them or he gives them a name to call, so he tries to create as many opportunities as he can.

And the following comment from George, a student who entered MIC with the intention of being a music journalist:

> Before going to MIC I loved the idea of being a music journalist. But the turning point for me was probably in year twelve when it was kind of like "Okay, what do you want to do?" and I was thinking music journalism doesn't really appeal to me that much as it did when I first went there. I don't know why it sort of drifted away. But the deciding factor in why I wanted to be a teacher was because I had phenomenal and inspiring teachers at MIC. You know, each one of them is so passionate about the industry that they work in, not just the education industry but they each have a connection to the music industry. Just seeing that passion and seeing how they can make kids want to learn, want to turn up to class; that really resonated with me and I really decided that this is something I wanted to do. And yeah, so that's always been a big part of why I wanted to study teaching. I wanted to be like the people who made me love going to school.

Some students at MIC were open about their personal clashes at their previous school and the topic of being *at risk* often arose. The notion of the at-risk student is well established in educational discourse and generally used to describe students in deficit ways,[14] particularly who are potentially facing exclusion or non-completion of their studies. Young people who do not subscribe to narrowly defined social norms[15] are

often described as being at risk. Year 11 student, Madeleine, provided her perspective:

> At my previous school, I was considered an at risk student.
>
> How come?
>
> Really silly things. I wore nail polish to school once and that just got the teacher on my bad side.

Like Fish, we find this framing of students as being at risk, or being problems to solve, quite troubling given that it "suffocates the notion of agency"[16] and reduces students to those who have education *done to them*. While there are many students at MIC who would easily fit into the category of being at risk, we have found that they respond positively when settling into the school, when the labels are removed and what is considered socially normal is broadened to accommodate student diversity and difference. As we show, the narrow definitions that suffocate agency also include power and policy agendas about what education should *do*, what it means for young people to be autonomous, creative and when given the opportunity, how they rise to take charge of their own learning.

For many young people identified as at risk, the chance to succeed at school "means having to suppress their own identities and act within a narrowly defined and institutionalised view of what it means to be a 'good' student".[17] Emerging from inside MIC are the perspectives about the many benefits that occur when young people are given space and the opportunity to explore their identities and to take personal control of their becoming. Of course, in a broad educational endeavour, preparing for the world of work is part of the goal of schooling but students in these cases are given permission to take control of their own paths.

As we described in Chap. 1, the cohesive community and family spirit at MIC is a vital part in getting students motivated into learning and to positive life changes. A number of individual interviews with the students confirmed this and Brett also offered comment. While not painting a romanticised picture, he stated:

> Kids will call it family. I think on some of the survey forms a couple of kids mentioned this and one kid actually said, this is my first family, not my second family and it's kind of interesting, we get that a lot. It's like a

family here and that's got plusses and minuses. The big plus is that they do support each other. The difficulty is if there is friction and a fracture it's actually amplified because it's a small community and if I'm being isolated or I've done something to aggravate the whole group, wow and that takes some management but the good thing is because we're so small and flexible we can stop everything, pull them all together, "Let's talk about this, as a group let's have a family meeting if you want to call it that, let's talk about this". "Let's talk about what happened on Facebook last night and why that's important".

The students at MIC learn about accountability through the deliberate climate of moral and social trust and responsibility. They are not massaged, controlled or manipulated into being accountable through strict adherence to suffocating rules and regulations. We note the discussion by Mockler and Groundwater-Smith, who describe the demise of democratic accountability in the age of compliance.[18] Their discussion indicates that in an ideal situation, moral and social accountability actually go hand in hand with responsibility and building institutional and personal trust through moral and social responsibility, which then reduces the need for overly regimented and contracted forms of accountability.

Problematically and undemocratically, the unsettling narrow regimes and mandates of neoliberal enforced contractual accountability regulations posing a significant threat to responsibility. Students and teachers are simply not to be trusted. They need to be made accountable through micromanagement, with rules and regulatory lists that include a scripted curriculum and rigid professional standards. Mockler and Groundwater-Smith also quote O'Neill in expressing doubt that "the present revolution in accountability will make us all trustworthier".[19] O'Neill believes that what is required is a different revolution, one that takes us towards *intelligent accountability*,[20] and which focuses on good governance and the building of social trust.[21] Smyth gives weight to this argument and the negative intrusion of accountability without trust, arguing:

> There can be little doubt from the accumulating research evidence that as conditions conducive to learning in schools deteriorate through emphases on accountability, standards, measurement, and high stakes testing, that increasing numbers of students of colour and those from urban, working class, and minority backgrounds are making active choices that school is not for them.[22]

Politics aside, for our work with MIC, we are also informed and motivated by our philosophical and methodological connections to the tact and sensitivity described by Van Manen about the need to witness how students see the world and to try to understand things from their perspective.[23] We resonate with the notion of connecting to the lives of young people and see this as an affective complement to our critical and political approach to theoretical engagement with the issues. Together with a resonance with the power and value of personal narrative, this has persuaded us to include quite large tracts of interview transcript (particularly in this chapter) in order to allow our participants to speak for themselves. The following lifeworld story by Selly, an MIC graduate, is an example.

Selly's story is presented in detail[24] as reflections on the meaning of MIC in her life have revealed poignant insights into personal creativity. Her personal interests are described as being supported and reignited through the MIC experience after having been "suppressed" in a previous mainstream school setting. Selly recollected thoughtfully about her experience and a unique point of difference is that she is passionate about painting and is focussed on an art career. We were particularly interested in how visual art was accommodated at a music school. In her articulate response, Selly reveals sensitive insight into perceptions of self and personal creativity but also to the way that MIC approached and accommodated special interest, acknowledging and supporting the pursuit of the dreams of one individual.

> MIC was the best two years of my life. Even though it wasn't predominantly focused on an art curriculum but the creative foundations applied to every subject. So Maths was made interesting because they related it to financing a music tour and things like that, so I was engaged that way. But even in everything they taught they tried to apply some sort of creative foundation or creative application so that it could engage the students. Although it was a music-based school, Brett and Charlie and a lot of the other teachers tried as hard as they could for every student, regardless of their career path or their interests.

And about painting:

> As a child, I went to a Steiner school where they focussed on developing your individuality and your talents and your interests, and intriguing you

with nature and craft and art, before forcing you into mathematics and English, things that you didn't understand at that age. So I grew up quite creative and always felt connected to nature and I've felt very strong in myself and independent and I've always had a sense of who I am, and I think that's set me apart from a lot of my friends who haven't had that Steiner upbringing. I've always known what I've wanted to do. And I'd got you know sort of off-track along the way sometimes but have always come back and I've had that foundation to rely on. And a lot of my friends who grew up in state schools and were conformed or suppressed from a very young age haven't really had that so they've resorted to, you know… a lot of them are depressed, a lot of them have anxiety, and a lot of them are lost because they were never able to develop that foundation or that independence, or a knowing of who they were at a young age.

After Steiner, from year seven to year ten I was at a state school, and I was completely out of my element, completely out of my zone. Although it was good to experience a state school because that's reality and that's what a lot of kids face, and then when I came to MIC I was like 'Oh, I'm home again!' And I just slotted right in and I felt so comfortable, and I remember the first day at orientation and there was probably just under eighty of us, so two grades combined. And I was sitting there and Brett was talking and the teachers were surrounding him, and I was just so beside myself. And I went through the day and I met all these new people that were crazy talented people, and then we had open mic sessions in the afternoon and a few of the year twelves did performances.

Mum picked me up that afternoon and I just hugged her and cried, I just let everything out, because I was so overwhelmed at how… absolutely I just felt the love as soon as I walked in the door, like I haven't had that since I was in year six. And I was so overwhelmed, the people were so talented, they were so happy. They were… they felt comfortable to express their humour, their individuality, their personality. And I was just like wow I haven't had that in so long. And as time went on I just felt so comfortable to be myself there, and I was doing really well in my assignments and having fun with the teachers. And I think the biggest thing for MIC, besides the whole curriculum that they apply, the philosophy or whatever; I think the teachers are the main source of everything. Because, the first time I went there I was welcomed. I felt comfortable having chats just like I would with my friends. And it just made my learning environment so much more relaxed, and so I was able to fully express if I was struggling with something. Even personally, they would just go to such lengths to make sure that you felt okay in your environment, and that you were

learning to the best of your ability. They went to a lot of lengths for me, to make sure that I was okay.

It's quite strange when you step out of that environment and then you see other school students yelling at each other, swearing at each other, bullying each other, and you're just not subjected to that kind of behaviour at MIC. Like I'm not subjected to that as everyone is so accepting at MIC. And everyone's really individual, so… it can be a bit intense because everyone feels so comfortable to speak up. I mean it can get pretty intense sometimes and we have… even between the teachers and students and everyone stands their ground and they're not afraid to express how they feel. So I think that's really good, but it never gets serious, it never gets anything more than just a conversation. So I think it's the students and the teachers that have a massive role to play in how successful and rewarding the MIC experience is.

Selly's story is one of engagement through rediscovering personal passion and creativity that had been lost for a while before arriving at MIC. Cora's recollections, on the other hand, reveal a different path to MIC and she recounts a life of rebelling against school and one where she would have been considered at risk. Similarly, her story also teaches us about the power of acceptance. We asked her about her last school situation and how it compared to life at MIC:

All my life I have never really been like, if people tell me what to do, I just won't do it. So like, I don't conform to anything. And teachers would always demand me to do things and stuff and I just like, pretty much revolted against whatever they said, so I was just like "I'm not going to do what you tell me", and then, yeah, I just got in a lot of trouble at every school I went to.

Would you say you were a bit of a rebel?

Yeah, cos there's so many rules, over pointless things, like you're not allowed to wear certain socks or whatever, and I'm like, pretty sure I can wear these socks cos it's not illegal and it's not going to kill anybody.

And what's different here?

I think here's more, a lot more accepting of who you are, and you don't really get judged for what you're interested in because we're all so different but alike at the same time I guess? And yeah, I don't know it's just like

a lot more accepting and more fun to be here I guess. It doesn't feel like school.

Bec had the same kind of feeling about rules and regulations. We asked:

What were the issues with your previous school that made you want to really focus on this?

Everything was wrong with my old school. For a start, the uniform policy was just stupid, like getting thrown out of class for having a piercing is just stupid.

Gabrielle had similar experience and a release from previous restrictions:

So my old private all-girls school was so like tight on like uniforms and everything you had to do. So uniforms were like pink and you had to have ribbons in your hair, you couldn't have loose bits hanging out, not even a fringe. And it was just really, really strict, and when you come here it's like, 'Okay you can dress like you normally would on a weekend, and you can come to school in that'. And we're like 'Okay, that's, wow...' like it's so much different but it's less restricted.

Questions need to be continually asked about how much space young people should be given with regard to what is considered as socially normal before applying penalties that force them back into corners. As te Riele and colleagues declare, "recognition of the emotional elements shaping the lives of young people necessitates amore caring approach to what is normally construed as 'misbehaviour' in other settings". They go on to state that the particular alternative schools selected for their case studies had "found patient and creative ways to respond so as to ensure their students were provided with a second (third/fourth/fifth ...) chance".[25]

When initially introduced to MIC, we were interested to learn if a community of diverse students with different musical tastes and interests could get along well together. Any thoughts that this might be a group of seemingly rebellious and troubled youth without interests or common aims, goals or values were soon dispelled. The connected curriculum, tailor-made for MIC students has a socially cohesive effect. While the climate of trust and responsibility is a big contributor, we have written elsewhere on how music is the glue that creates social unity and a positive

community spirit at MIC.[26] An important part of the common ground is the degree to which the students are "into" music and the central part it plays in their lives. We asked for comments about personal feelings and the value of music:

> I can't explain it. It's like everything. It's like my whole life.
>
> Year 11 student

> It's like life. It's like my other friend that I had because I didn't really talk to people so kind of grew up with music and that's what I focused on, instead of talking to other people I just chilled and played the piano or guitar.
>
> Year 11 student

Planning the life of the school around a connected curriculum, with music at its heart, satisfies what Connell describes as *curricular justice*. This is to say that the curriculum has been purposefully "organised around the experience, culture and needs of disadvantaged members of society" and the situation at MIC works well because the main decisions about curriculum have become "de-centralised right down to classroom level and teaching itself is separated from the audit mechanisms of competitive testing".[27] The notion of curricular justice is cemented in place because Brett and his colleagues, while de-centralising, have designed a curriculum that starts not with pre-empted ideas of what needs to be taught using a prescribed curriculum, but by attending to what makes young people want to learn.[28] Bec, a Year 11 student, reveals the way MIC moves beyond the script and a pre-empted curriculum:

> At my old school we had no freedom to learn what we wanted. It would be like, you have to learn this and you cannot study anything else. Whereas, at this school, teachers will work with us... like, "What do you want to learn? Let's see if we can cater to that".

And later, she adds:

> My music teacher was very classical orientated. We didn't get to learn anything that we wanted to learn. I studied classical music for basically three years, all theory. Rarely ever got to do anything we wanted to do, so this school was a big change.

We also note how MIC students, coming from diverse backgrounds and with varied aesthetic musical preferences, collaborate musically with their peers and teachers. Musical taste, which is a contributor to personal and group identity, can potentially separate and divide as it is often very narrow in adolescents, and "private or group identity is often accompanied by rebelliousness, defiance of authority and the need for freedom of expression".[29] However, once at MIC the students become not only tolerant of musical difference but recognise it as common ground and a reason why they are here.

As we argue further in Chap. 5, the students at MIC live and work in a spirit of co-operation and this contributes to the positive school community vibe. Absent is the need for students to compete with each other. This contrasts with the way in which competitiveness has become a coercive motivator in many of our mainstream education systems (and most social and professional aspects of life). Through non-competitive teaching methods and by allowing the students to be actively engaged in what interests them, pedagogical mechanisms of competition are made redundant at MIC. This leads us to reflect on global trends and to ask whether we have engaged critically enough with the concept of competition as an educative tool and societal doctrine? Noddings reminds us of the importance of collaboration over competition and argues that we need to "promote co-operation in our schools and reduce the current craze for GPAs (Grade Point Averages) rankings and test scores" and her pointer is that this "in no way entails a reduction in the commitment to excellence".[30] Is it the case that competition is so culturally and societally pervasive that we are like fish swimming in water, unaware of the medium in which we live?

Miller argues that "so saturated is our society with the spirit of competition that we allow its effects to go unchecked because we simply don't recognise, or worse yet, fail to understand how it decays the very essence of art and creativity". He goes on to suggest that while considered as a motivator towards excellence competition is actually the antithesis of creativity because it order for competition to work, people must be measured by the same standard when originality and creativity move beyond standardisation.[31] And music education is the loser[32] when it is driven by competition and competitions. This is a bold statement but MIC offers an alternative in this regard, and we believe that it is time for wider support for alternative non-competitive teaching methods, not only in music education but also across the board.

Critical discussion must continue on how much the drilling of the
minds of the young into a world of competition actually contributes to
the development of character, whether it inflates self-serving individual-
ism and to what degree this contributes with a negative impact on the
development of active citizenship and socially just societies. The incon-
gruity of educating for care, democracy, social justice and active citizen-
ship is at odds with what some might put it bluntly on how a "dog eat
dog world" is modelled and encouraged in our schools. The doctrine
of compete or survive in a climate of economic competitiveness[33] now
drives the governance of our schools and it trickles down to our teachers
and students to become even further embedded into school life. Most
importantly, we note the attitude of some MIC students who indicate
that intuitively they reject the need to compete and they need not be
pushed. Ari provides a good example. He states:

> I see myself as a very humble, laid back person and I don't see schools as a
> competitive environment, but the old school kind of saw itself and all the
> other private schools as the enemy and very kind of school spirit, ra, ra, ra
> and I was just not into that. At the old school it was really just kind of like
> shoved down your throat.

Also, Lauren has worked it out that a focus on individual aspirations and
potential is perhaps a more democratic route to success and achieving
"your best":

> Yeah, it's maintaining your best, not the school's best. People, I've had
> friends that are told they can't go for an OP[34] or anything like that because
> they'll bring the whole school's grades down, like they won't get as better
> mark as the school. This school, it's not like that. You're here to get your
> best, not what the school wants.

We have been heartened by MIC student stories of self-empowerment
and transformation. This is especially so as many had felt restricted, been
in limbo or generally stuck in previous school contexts. We asked George
what the transition from the previous school to MIC has been like:

> I've always been a public school child but I felt that the school that I was
> at wasn't really noticing me as an individual - not that I really stood out
> in anything, but you know like you just sort of... you know, unless you're

really, really 'up here' you don't get noticed, and it wasn't really meeting what I wanted to get out of school. And once I started going to MIC it was a big change, and I wouldn't say that I was lost for a while but I think I was finding myself, it's kind of the opposite of being lost. And I think my personality really came out by hanging out with the people that I met at MIC.

A recurring theme from the students relates to the overly academic pushing demanded in previous mainstream school experience. We are reminded of Robinson's observation that we privilege academic intelligence above other forms and that driving students towards university and intellectualism is the main goal of most of our schools.[35] It was clear for some MIC students that this was not their specific way of working, seeing the world or particular form of intelligence. It is no wonder they were fighting against the conception of how they should be. Biesta adds weight to this conversation by describing schooling as a combination of three domains: qualification, socialisation and subjectification. He suggests that an overemphasis on any one is problematic, such as the current focus on qualification, where schooling and academic success is seen as a vehicle for work-readiness and economic success. He argues "excessive emphasis on academic achievement causes severe stress for young people, particularly in cultures where failure is not really an option".[36] Trey provided her perspective:

> My last school was all very academic and was more focused towards doctors and zoologists and all those big fancy high-paying jobs, and it was just not what a lot of people want to do. Not what I wanted to do—It was a public school but I guess with that they were trying to push us in a direction to make them get a better reputation?

Gavin found that the change at MIC gave him new focus that contrasted with the kind of academic pushing experienced earlier. He couldn't make a connection to it:

> I actually want to do well and also because it's fun here I can actually relate to the subjects and I can relate to pretty much everything we do to real life whereas at my old school I wasn't really able to do that because it was all kind of redundant, you know what's the point of doing this, it's not going to actually help me whereas stuff here is kind of like, I could apply everything to real life.

Riley explained how MIC gave her space to flourish in a way that was more productive than being pushed into a specific direction:

> Yeah I was amazed at how much more creativity came out of me when I was in a more open environment, so what was more suited to me, like maybe like the individuality of each class is amazing and just when you kind of just find yourself at the school they give you a lot of free space to think and to roam, and you can just kind of pick up the pieces.

If asked to classify, we would frame MIC in the terms of Smyth and colleagues who might refer to this kind of school as a *relational school*.[37] This is where a focus is given to the importance of relational power and relational trust[38] through an ethic of care, reciprocity and respect. However, in the current context of schooling it is very difficult for teachers to prioritise the relational environment,[39] given the performative emphasis on standardised performance and accountability. As such, students and teachers suffer. We are aware that much of what assists the relational environment at MIC is the great degree of support given by teachers, and because this is a small school, creating relational space[40] can be prioritised. Authority and power are not dominant but put into a democratic, relational perspective. Gabrielle tells us that:

> Every single teacher is like the most supportive person. Even if you don't ask for help they will walk around and they'll go, "Okay, we know you're struggling, let's put in a tutoring session, or I'll take you out of the class for fifteen minutes and I'll talk to you about it". Every single teacher at MIC is so supportive of everything, like even the decisions you make. Like... say if you're doing a film critique and stuff, and they might say, "This could be enhanced by...". So they'll actually help you with the language and they'll teach you what type of language to use while writing that stuff.

Gavin had described the school as relaxed and easy and we asked him to elaborate further:

> Well probably mainly the teacher –student relationship. It's kind of more like a person to person relationship than a teacher –student relationship. I guess that's a big part of it.

Sarah offered her perspective when we had asked "What it is that makes you happy here?" She indicated that the small size of the school contributes, in addition to important relational benefits in place:

> I think they treat you like an adult and everyone gets along. I don't know if that's just because it's a small group of people but I think yeah, it is a good environment to be in and everyone just sort of—you know because we all have the same interests too, I think that has a lot to do with it, we're all into music and passionate about it.

Riley discusses relationships, trust and power, stating:

> We get along with the staff members really well, like I don't know how to explain it. It's kind of like because there's no hierarchy of like Principal's the boss-boss and then the teachers they're your boss and then it's yourself and all of your peers around you. It's kind of like they're also your friends, so you know that you can trust them with information if you need to speak with someone, or you need to run something and they can help you like figure it out yourself. It's just a really, really cool environment.

Finally, we have no way of knowing what all this will mean for the future of the students who we have spoken to, for the enduring outcomes of education[41] are impossible to know without either guessing or conducting a lengthy longitudinal study extending far into the future.[42] Will the MIC experience result in happy futures, confident, creative and resilient people who are adaptive and most importantly, do feel good about themselves? Will they have developed socially just, democratic dispositions and operate as active citizens? We cannot comment. But what we do know is that in the present, the MIC experience of a relational, trusting space satisfies what Fraser describes as offering recognition and representative justice.[43] This occurs through pedagogies that afford students the opportunity to have a voice in a participatory democracy. Further, the creation of inclusive learning spaces, where students have agency and autonomy "will privilege and work with students' identities and funds of knowledge in ways that avail the sense of individual and collective political agency that is requisite to nurturing active citizenship".[44] We should not miss opportunities for this kind of nurturing and to position students with autonomy while engaging them critically in issues that concern them and their own learning.

We turn now to consider the experiences of teachers in Chap. 4, but will return to consider further accounts of current and former students' lives and experiences in Chap. 5, where we consider the importance of community and culture in connecting them to a meaningful education. From our perspective, the voices of young people must be central in any attempt to create a more relational space of trust and responsibility, as well as being a core part of the project of social justice in schooling.

NOTES

1. te Riele (2007). We also discuss the issue of school choice in Chap. 6.
2. McInerney and Smyth (2014, p. 240).
3. McLaren (2007).
4. Mockler and Groundwater-Smith (2014). For the sake of broad understanding, the authors problematise the use of student voice. Importantly, they begin by outlining the United Nations' *Convention on the Rights of the Child*. The core principles of the Convention support our case for consulting the students of MIC.
5. Smyth (2016, p. 319).
6. Keddie (2012, p. 264).
7. See the *Australian Professional Standards for Teachers*, Australian Institute for Teaching and School Leadership, 2014.
8. Liasidou and Symeou (2016, p. 5).
9. See McGraw (2011).
10. Apple (2007) and also see discussion by McGregor (2009, p. 346).
11. Mockler and Groundwater-Smith (2014, p. 8).
12. Smyth (2006, p. 279).
13. Donald Trump was elected President of the USA in November 2016, on a platform of deception and what has come to be labelled "alternative facts" and "fake news".
14. te Riele (2007).
15. Thomson (2002).
16. Fish (2017, p. 95).
17. Smyth (2006, p. 290).
18. Mockler and Groundwater-Smith (2014, p. 32), discuss how responsibility it is replaced or subverted by new forms of accountability. They quote Biesta who describes how, "new forms of accountability render teachers more accountable to the various regulators than to the public, or the communities of students, practitioners and parents they serve".
19. Mockler and Groundwater-Smith (2014, p. 32).
20. O'Neill (2002).

21. Mockler and Groundwater-Smith (2014, p. 57).
22. Smyth (2006, p. 279).
23. See Van Manen (1990, 1991).
24. This account is presented in length because Selly, in interview, offered an insightful and articulate personal narrative and with little prompting from us.
25. te Riele et al. (2017, p. 64).
26. Cleaver and Riddle (2014).
27. Connell (2012, p. 682).
28. Smyth et al. (2013, p. 300).
29. Zillman and Gann (1997).
30. Noddings (2013, p. 10).
31. Miller (1994, p. 31).
32. This is the point made by Austin (1990), who questions why we need to compete. He explores "the myths of competition" and questions whether "competition provides all students with a healthy experience, or are some students destined to flounder under such setups?", p. 2.
33. Wrigley et al. (2012). They describe how globalisation and economic interests have contributed stating, "At a policy level, educational achievement has been redefined as 'effectiveness' within the terms of competitive market systems", p. 96.
34. Overall Position. Lauren is referring to the statewide ranking system, which is based on achievement in "authority" subjects and scores will determine tertiary entrance. Your OP shows your achievement in comparison to other graduating students.
35. Robinson and Aronica (2015).
36. Biesta (2015, p. 78).
37. Smyth et al. (2010).
38. Smyth (2012).
39. te Riele et al. (2017).
40. See Kraftl (2013) for an interesting discussion on spatiality in alternative education, which includes the physical and geographical space, but also relational space.
41. Barone (2001).
42. However, in Chap. 5 we report from graduate students who reflect back to their MIC experience, which helps give some sense of the longitudinal effects of MIC on the lives of students.
43. See Fraser (1997, 2010, 2013), as well as our further discussion of her conception of social justice in Chap. 6 and how we see it applying to MIC and schooling more broadly.
44. Lingard and Keddie (2013, p. 429).

REFERENCES

Apple, M.W. 2007. Whose markets, whose knowledge? In *Sociology of education: A critical reader*, ed. A.R. Sandovik, 177–196. New York, NY: Routledge.

Austin, J. 1990. Competition: Is music education the loser? *Music Educators Journal* 50 (6): 21–25.

Barone, T. 2001. *Touching eternity: The enduring outcomes of education*. New York, NY: Teachers College Press.

Biesta, G. 2015. What is education for? On good education, teacher judgement and educational professionalism. *European Journal of Education* 50 (1): 75–87. doi:10.1111/ejed.12109.

Cleaver, D., and S. Riddle. 2014. Music as engaging, educational matrix: Exploring the case of marginalised students attending an 'alternative' music industry school. *Research Studies in Music Education* 36 (2): 245–256. doi:10.1177/1321103X14556572.

Connell, R.W. 2012. Just education. *Journal of Education Policy* 27 (5): 681–683. doi:10.1080/02680939.2012.710022.

Fish, T. 2017. Therapeutic responses to 'at risk' disengaged early school leavers in a rural alternative education programme. *Ethnography and Education* 12 (1): 95–111. doi:10.1080/17457823.2016.1216321.

Fraser, N. 1997. *Justice interruptus: Critical reflections on the "postsocialist" condition*. New York, NY: Routledge.

Fraser, N. 2010. *Scales of justice: Reimagining political space in a globalizing world*. New York, NY: Columbia University Press.

Fraser, N. 2013. *Fortunes of feminism: From state-managed capitalism to neoliberal crisis*. London: Verso.

Keddie, A. 2012. Schooling and social justice through the lenses of Nancy Fraser. *Critical Studies in Education* 53 (3): 263–279. doi: 10.1080/17508487.2012.709185.

Kraftl, P. 2013. *Geographies of alternative education: Diverse learning spaces for children and young people*. Bristol: Policy Press.

Liasidou, A., and L. Symeou. 2016. Neoliberal versus social justice reforms in education policy and practice: Discourses, politics and disability rights in education. *Critical Studies in Education*: 1–18. doi:10.1080/17508487.2016.1186102.

Lingard, B., and A. Keddie. 2013. Redistribution, recognition and representation: Working against pedagogies of indifference. *Pedagogy, Culture & Society* 21 (3): 427–447. doi:10.1080/14681366.2013.809373.

McGraw, A. 2011. Shoving our way into young people's lives. *Teacher Development* 15 (1): 105–116. doi: 10.1080/13664530.2011.555228.

McGregor, G. 2009. Educating for (whose) success? Schooling in an age of neoliberalism. *British Journal of Sociology of Education* 30 (3): 345–358.

McInerney, P., and J. Smyth. 2014. 'I want to get a piece of paper that says I can do stuff': Youth narratives of educational opportunities and constraints in low socio-economic neighbourhoods. *Ethnography and Education* 9 (3): 239–252. doi:10.1080/17457823.2013.873349.
McLaren, P. 2007. *Life in schools: An introduction to critical pedagogy in the foundations of education.* Boston, MA: Pearson.
Miller, R. 1994. Dysfunctional culture: Competition in music. *Music Educators Journal* 81 (3): 29–33.
Mockler, N., and S. Groundwater-Smith. 2014. *Engaging with student voice in research, education and community: Beyond legitimation and guardianship.* Dordrecht: Springer.
Noddings, N. 2013. *Education and democracy in the 21st century.* New York, NY: Teachers College Press.
O'Neill, O. 2002. *A question of trust: The 2002 Reith lectures.* Cambridge: Cambridge University Press.
Robinson, K., and L. Aronica. 2015. *Creative schools: The grassroots revolution that is changing schools.* New York, NY: Penguin Random House.
Smyth, J. 2006. Educational leadership that fosters 'student voice'. *International Journal of Leadership in Education* 9 (4): 279–284. doi:10.1080/13603120600894216.
Smyth, J. 2012. Problematising teachers' work in dangerous times. In *Critical voices in teacher education*, ed. J. Smyth and B. Down, 13–25. Dordrecht: Springer.
Smyth, J., B. Down, and P. McInerney. 2010. *'Hanging in with kids' in tough times: Engagement in contexts of educational disadvantage in the relational school.* New York, NY: Peter Lang.
Smyth, J., P. McInerney, and T. Fish. 2013. Blurring the boundaries: From relational learning towards a critical pedagogy of engagement for disengaged disadvantaged young people. *Pedagogy, Culture & Society* 21 (2): 299–320. doi: 10.1080/14681366.2012.759136.
Smyth, J. 2016. The Australian case of education for citizenship and social justice. In *The Palgrave international handbook of education for citizenship and social justice*, ed. A. Peterson, R. Hattam, M. Zembylas, and J. Arthur, 307–325. London: Palgrave Macmillan UK.
te Riele, K. 2007. Educational alternatives for marginalised youth. *The Australian Educational Researcher* 34 (3): 53–68. doi:10.1007/BF03216865.
te Riele, K., M. Mills, G. McGregor, and A. Baroutsis. 2017. Exploring the affective dimension of teachers' work in alternative school settings. *Teaching Education* 28 (1): 56–71. doi:10.1080/10476210.2016.1238064.
Thomson, P. 2002. *Schooling the rustbelt kids: Making the difference in changing times.* Crows Nest: Allen & Unwin.

Van Manen, M. 1990. *Researching lived experience: Human science for an action sensitive pedagogy.* Albany, NY: State University of New York Press.

Van Manen, M. 1991. *The tact of teaching: The meaning of pedagogical thoughtfulness.* Albany, NY: State University of New York Press.

Wrigley, T., B. Lingard, and P. Thomson. 2012. Pedagogies of transformation: Keeping hope alive in troubled times. *Critical Studies in Education* 53 (1): 95–108.

Zillmann, D., and S. Gan. 1997. Musical taste in adolescence. In *The social psychology of music*, ed. D.J. Hargreaves and A.C. North, 161–183. Oxford: Oxford University Press.

The Freedom to Teach

One of the things I love about MIC is the freedom that we have as staff but also the freedom that students have as well. And that's something that is really important to me, that I'm allowed to not only just do my job but to develop programs and activities that are important to me. I'm given that license to do that.

Charlie, English teacher

Abstract This chapter addresses the experiences of the teachers who work at Music Industry College. It breaks down the curriculum, pedagogy and assessment that underpins the daily teaching experiences in the school, as well as provides insights into the hopes and aspirations of the professional educators who form part of the school's community. Multiple vignettes are used to demonstrate approaches to curriculum and pedagogy and how these link to the importance of connectedness at Music Industry College.

Keywords Teachers · Curriculum · Pedagogy · Freedom · Care · Social justice

Teachers face a wide range of professionally disempowering conditions generated by the current education policy context of regulation, reform, management and control.[1] Our concern is with how teachers are

© The Author(s) 2017
S. Riddle and D. Cleaver, *Alternative Schooling, Social Justice and Marginalised Students*, Palgrave Studies in Alternative Education, DOI 10.1007/978-3-319-58990-9_4

manipulated and punished by market-based control systems[2] in ways that have detrimental effects on their lives as well as the lives of the students who are in their care. Increasingly, many teachers are "damaged by the anxieties and stresses produced by the changing nature of the profession and from being disciplined into a particular form of teacher that conflicts with the construction of the teacher they would like to be".[3] Our focus for this chapter is to counter the complex array of issues faced by the teachers and their profession by focussing on the notion of *the freedom to teach*, and what this might offer for teachers, students and schooling more broadly. We have set this as our theme because MIC teachers offer us discussion points strongly related to the clamping down on teacher autonomy. Before discussing the negative mechanisms bearing down on teachers, we begin by highlighting the political and social complexity of the profession. Smyth observes:

> Teachers' work has always been an avowedly political process, long characterised by decisions about what knowledge gets taught, and what gets omitted; whose view of the world is privileged, and whose is denied; what forms of pedagogy are inclusive, and which are exclusive; and whose interests are served, and whose are marginalised and excluded.[4]

The social complexity is highlighted in *Teachers' Work*, where Connell describes how "parents often judge teachers as if they were surrogate parents, kids treat them as a cross between a motorcycle cop and an encyclopaedia, politicians and media treat them as punching-bags".[5] One wonders, in the light of the complex nature of teaching why there is not more respect, support and trust offered to teachers. However, there is evidence to suggest that teachers' work is subject to sustained distrust,[6] along with increasing levels of surveillance,[7] which amounts to a persistent attack on the profession, particularly from the corporate media and conservative politicians who have bought into the neoliberal myth of teachers as requiring fixing.

In championing democratic, ethical education and the plight of teachers, Noddings argues, that "if we value education and the democracy it supports, we should protest this attack and put an end to it".[8] We feel that this is at the heart of the argument to give teachers the freedom to teach, rather than continuing down the path of reducing teachers to simply being technicians, while education policy-making happens at a far distance from the classroom. The exclusion and reduction of teachers and their work "amounts to a process of 'deskilling' teachers, as control

over their work is increasingly diverted to impersonal mechanisms of sur-veillance".[9] Like Lingard, we are concerned that the taming and techni-cising of teachers' work reduces pedagogical possibility via strictures of efficiency and accountability.[10]

As part of the epidemic of economic rationalist school reform, the application of corporate business structures to education challenges the very meaning of teachers' work. A culture of control, compliance and competition mandated through high stakes testing and reductive accountability measures has created a de-personalised climate that directs attention less and less from a consideration of who teachers are, what they value and their professional creativity and judgment, towards a focus on how they perform.[11] As Mockler and Groundwater-Smith argue, there has been a subtle but significant "shift from teach*ing* quality to teach*er* quality".[12] Ball also highlights the complexities when arguing that these "technical rationalities of reform" do not simply change what teachers do but demand highly personal changes in who they are.[13] He states that:

> The policy technologies of market, management and performativity leave no space for an autonomous or collective ethical self. These technologies have potentially profound consequences for the nature of teaching and learning and for the inner-life of the teacher.[14]

To work within these policy technologies, teachers must develop new roles, subjectivities and values, together with a vocabulary and corporate jargon suited to the new model. Ball provides some examples of the new jargon teachers must adopt. He mentions how "learning is re-rendered as 'cost-effective policy outcomes'; achievement is a set of 'productivity targets', etc.".[15] Stress builds when teachers must focus on narrow con-ceptions of learning and achievement that are assembled specifically for ease of measurement and when they must then make themselves audit-able.[16] Quantitative views of the teaching profession hollow it out to a crusty shell without a beating heart. As Connell suggests, "the humanist model of a good teacher becomes an anachronism" and is now replaced by a reductive technical mode rather than true professionalism, "decom-posed into specific, auditable competencies and performances".[17]

Furthermore, Smyth maintains that the defining features of educa-tional policy over the last twenty years have included "(1) blaming stu-dents; (2) castigating schools; and (3) getting muscular with teachers" and that "these are the three things that we don't need more of".[18]

While issues surrounding items 1 and 2 are examined elsewhere in this book, our focus in this chapter is on the specific experiences, perspectives and critical comments offered to us by the teachers at MIC. In doing so, we blend their stories together with theoretical points for critical discussion about alternative education and teaching. We contend that MIC offers an alternative narrative in counter to these assaults on students, teachers and schools, where enormous amounts of time, energy and creativity are committed to carefully working within and against the grain of policy simultaneously[19] in order to design artfully enhanced curriculum that meets government mandated accreditation requirements, while still considering the specific needs of individual students and in ways that work to motivate and inspire them.

We agree with Giroux, who argues that teachers need to be intellectuals, in order to "reconsider and, possibly, transform the fundamental nature of the conditions under which they work. That is, teachers must be able to shape the ways in which time, space, activity, and knowledge organise everyday life in schools".[20] This is not an empty statement, but one that requires a complete reshaping of what teachers' work is, from one that is simply the delivery of predetermined curriculum materials and assessment tasks to a more carefully formulated mixture of pedagogy, curriculum and assessment that has social justice at its heart. Lingard mentions how "the quality of pedagogies is an important social justice issue in education".[21] Indeed, we note that "issues of pedagogies, social justice and inclusion cannot be considered in isolation from those of curricula and assessment".[22]

McLaren[23] argues that teachers are social and moral agents, not simply employees who deliver curriculum and assessment. Added to this, Giroux makes the following claims, which we present in full, as it is a clear presentation of the importance of pedagogy in connecting meaningfully to the lives of young people who have been excluded and marginalised from schooling:

> Pedagogy is not defined as simply something that goes on in schools. On the contrary, it is posited as central to any political practice that takes up questions of how individuals learn, how knowledge is produced, and how subject positions are constructed. In this context, pedagogical practice refers to forms of cultural production that are inextricably historical and political. Pedagogy is, in part, a technology of power, language, and practice that produces and legitimates forms of moral and political regulation

that construct and offer human beings particular views of themselves and the world. Such views are never innocent and are always implicated in the discourse and relations of ethics and power.[24]

We can see how it might seem that "there is something a little mysterious and evasive at the heart of the business of teaching",[25] although we do understand that there clearly needs to be a strong professional knowledge of curriculum and pedagogy, as well as a firm commitment to the project of education as a public good and schooling as one of the best vehicles currently available to deliver a more socially just and equitable society. Yet, it is worth remembering that teaching is a highly political act, and that, in the words of McLaren, "not only is it impossible to disinvest pedagogy of its relationship to politics, it is theoretically dishonest".[26]

Curriculum too, when centralised and standardised as a political act of governance and shifted to the *new managerialism*,[27] contributes to the malaise by redefining the professionalism of teaching to the delivering and implementing the ideas of others who are contextually distant. When narrow, "one-size-fits-all" curricula are mandated (and this applies to professional standards for teachers as well), teachers are stripped of autonomous ways of working. They become agents of agendas removed from their own interests, local contexts, professional understanding and knowing, and often having to shelve their insights, their time-based moment-to-moment judgments and intentions for the needs and specific interests of the students who are in their care.[28] In muscular fashion, accountability regulations evaluate student achievement targets to ensure that the narrow components of learning, identified for ease of measurement, have actually been met. Notably, in Australia, results are published by the media as league tables, ensuring that schools and teachers become accountable to the competitive market.

Importantly, Noddings[29] argues that teaching is a relational practice and that teachers must be committed to establishing important relations of trust and care in order to connect to the lives of their students. Likewise, in her book, *The Ethics of Care*, Held[30] makes the argument that teachers teach not because they are working from market principals of maximum economic gain or productive efficiencies, but rather because they work from a principle of social contribution to provide young people with a meaningful education.

Of course, this is not to suggest that all teachers work purely from a position of altruism and selflessness, yet it is worth noting that the primary aim of the teacher is not to make money, but to educate. As such, we would argue that there needs to be a much greater emphasis and valuing given to the notion of teaching as work that demands an ethic of care.[31] At the same time, we note Lingard and Keddie's[32] point that while care is a necessary but insufficient condition for social justice, they warn that it should not come at the cost of intellectual demand.

Teachers and teaching must be at the heart of any project seeking an educational emancipation.[33] While we find the notion of emancipation to bring its own sets of concerns, we do take the point that teaching cannot be relegated to the side, made devoid of life and humanity, and rendered a purely technical act of knowledge transfer and test administration. For this purpose, we find Giroux's[34] notion of *border pedagogy* a useful one. He says:

> Border pedagogy can help to locate teachers within social, political, and cultural boundaries that define and mediate in complex ways how they function as intellectuals who exercise particular forms of moral and social regulation. Border pedagogy calls attention to both the ideological and the partial as central elements in the construction of teacher discourse and practice.[35]

Giroux[36] argues for a more democratic public philosophy through border pedagogies that constructs new configurations of knowledge, power and culture, in order to reconstruct society in radically democratic ways. In a small way, this is what we see happening at MIC with the teachers, who are showing a deep commitment to the school as a place of democratic civic participation.[37]

Similarly, the Productive Pedagogies project found that high levels of support and care need to be combined with an intellectually demanding curriculum that connects to the sociocultural contexts of students.[38] Added to this, the concept of *socially just pedagogies,* which arose from the work of Lingard and colleagues,[39] is worth considering as a vehicle for developing a better-connected, more relational approach to teaching and learning for social justice. Such pedagogies involve intellectual rigour and demand, which are "less likely in today's policy context of high-stakes testing, which encourages scripted pedagogies".[40] Instead, Lingard and Mills argue that:

Socially just pedagogies require well educated teachers who know the research literature, but mediate it through a careful reading of the demands and specificities of their students, classes, locale, and place and space of nation and globe. Trust of teachers ought to be a feature of socially just schooling systems and schools. Policy mandating of pedagogies often works with an inherent mistrust of teachers. A professional development focus more often works with such trustful relations.[41]

There is no doubt that more trust is needed for teachers and more support for schools in general, in order to "constitute schools as reflective and inclusive communities of practice".[42] Teachers also need to be unafraid to openly discuss what Delpit[43] calls the *discourse-stacking* of society, where the inequalities and injustices of the system are hidden behind the discourses of meritocracy and individual choice. This can only happen in environments of high trust, mutual support and care.

The teachers at MIC have arrived from various mainstream school backgrounds and in interviews and conversations they gladly related details of experience, their critical and personal views about the transition to MIC. The collection of experiences they share offer particular insights into teaching beyond the mainstream and while much that we present is unique to teaching in an alternative schooling context, some content may be recognised as simply "good practice" existing in a wide range of education contexts. Nevertheless, in contributing to the discourse and further dialogue, our intention is that readers are free to resonate with or be confronted by these ideas of what a good education is. We think this is important, because, as James, the film and television teacher, points out:

At this school I feel like I can actually make a difference.

Importantly, we are concerned for "the inner life of teachers" and how they cope with the enormous pressures that they are put under on a daily basis. We are concerned about teacher's authenticity and integrity, seeing these as values leading to feelings of fulfilment and wholeness and the healthy balancing of a professional and personal life. We freely admit that these concerns, together with confronting issues of social justice, tended to rose tint the lens with which we looked, influencing the direction of some of our questioning and conversations with the teachers at MIC.

While we have written previously about the philosophies and practices of Brett's school leadership[44] and the ways that staff navigate the complex policy terrain of schooling,[45] here we are interested in uncovering some of the different factors at play in what we consider to be the ways that they are afforded the freedom to teach. We begin with a focus on Brett, the school founder and principal and then Charlie, the teacher of English, who is closely linked with Brett having been alongside him at the genesis of MIC. Stories and anecdotes from other teachers are also included to reveal the teaching life and the school's approach to pedagogy and curriculum.

Brett has worked at the rough edges and boundaries of education, having been immersed in alternative programs and with marginalised and low socio-economic communities prior to establishing MIC. At each of our many meetings with Brett, we were struck by the positive energy he maintains despite working long hours. His defining cause is in getting young people reconnected to schooling and feeling good about themselves while working for ways to engage them in enriched experiences that transform their lives. Each of our conversations is accompanied by enthusiastic outpourings about the daily work and life of MIC. Brett is keen and willing to share ideas and knowledge about current issues, and his stories of early life in teaching reveal deeply felt perspectives and essential elements of a philosophy of care. We find his intuitive pragmatism and plain speaking about important matters, refreshing. He engages us openly about his experience, expectations and goals and with the complex technicalities of school governance.

He holds deeply personal perspectives about the meaning of school to young people, in finding suitable solutions and alternatives and with much constructive criticism of bureaucratic restrictions and red tape. The process of setting up a school "from scratch" has certainly required a great deal of policy systems understanding and jumping through bureaucratic hoops with great patience. As a result, Brett is critically knowledgeable and well informed about many of the structures of mainstream schooling, the effects of over-regulation and accountability, the negative effects of standardised testing, the shoving around of young people and the pressures placed on teachers. As an educational leader, a particular skill he has is making seamless connections between theoretical considerations of education and policy and how to implement and manage these at the grass roots level. In the light of this, we are reminded of McLaren's description of a *praxis-orientated pedagogy*. This, as McLaren

describes, is "a pedagogy that bridges the gap between critical knowledge and social practice"—it involves *bringing theory into the streets*. This is certainly applicable to Brett for while working at street level he acts as a lynchpin and motivator for the betterment of the social life of the school and he "organises and mobilises students, parents and teachers" into a positive community within and surrounding the school.[46]

The importance of educational leadership in schools cannot be understated[47] and Brett's specific approach is through co-operation and with concern for social justice as he works at building and maintaining a sense of community at MIC. This is, without doubt, synchronous with the way many principals work or would choose to do so given favourable circumstances. However, Brett's style would apparently be termed "old fashioned" in the neoliberal scheme, which increasingly seeks to define school leadership within a managerial model obsessed with metrics and outputs. As Smyth and colleagues explain, when discussing the changing culture in neoliberal times, school leaders are under pressure to "redefine their roles in terms of corporate responsibilities and business values, rather than some outdated commitment to social justice".[48] Of course, we reject any suggestion that social justice is outdated, as we articulate at some length in Chap. 6.

Brett's commitment to an alternative educational environment differs from the "new hero of educational reform" or the "new technicians of transformation" whose managerial task would be to instil an attitude and culture of competition, compliance and accountability.[49] On the contrary, his approach inspires and encourages MIC teachers to work co-operatively without competing, being innovative and individual before being compliant, and accountable only in showing their commitment to the community and their teaching. As we reveal later, the teachers discuss with us how Brett's leadership engages them with possibilities and alternative ways of working beyond the mainstream expectations of their previous contexts.

Most students arrive at MIC with heavy loads, personal challenges and troubled stories about their previous school experiences, which we have already discussed at some length in Chap. 3. Many have felt disengaged, unmotivated and confused about direction and goals and prior to MIC, in their mainstream school contexts, many had been categorised as problematic, "at risk" or as "rebels". But *they* are not the problem! Brett's view is that it is the schools that have failed to engage the students. He recognises, from earlier experience in mainstream schools, how youth are

too easily labelled as "naughty kids" and "bad kids" and then "sacked" from the institutions. He states:

> In other places where I've been, the students have to serve the institution - and here we've tried to flip that. The institution is here to serve the kids. And we don't make a lot of rules for that reason.

Brett disregards what he believes are misdiagnosed labels and symptoms and remains committed to the notion of young people as being inherently capable, intelligent and creative.[50] This is in stark contrast to deficit views of young people that see them as requiring fixing.[51] When guiding students, Brett positively acknowledges the life story and private self of each by crossing over to their side to see where they are coming from. And they become aware of Brett's caring at their first interview with him to secure a place in the school. He creates rapport by acknowledging the individual and unique self of each and what they imagine for their own lives. This resonates with a description by Noddings of the component *confirmation* which is where the care-giving teacher "sees the cared-for as he is and as he might be—as he envisages his best self".[52]

An interview with Anne, the parent of A.J., provides a specific example of Brett's approach:

> My son was quite ill with a serious mental health condition and when he turned sixteen the previous school pretty much took the first opportunity to get rid of him. He had his interview with Brett and from that first meeting really, it was all about the future and moving forward. Brett really wasn't that interested in any of the back-story at all, but just was interested in who A. J. was and where he wanted to go. Yeah so it was a huge relief, for everybody.
>
> So, we understand that A. J. graduated from MIC last year, didn't he?
>
> Yes.
>
> So what's he up to now?
>
> He's at University, just started this week doing Law/Journalism Honours.

Most teachers, regardless of the school in which they are located, would acknowledge that they care about their students. However, in the context of large mainstream schools and classes the intimacy required to

create rapport, understanding and connection to individual needs and life stories, what students value and the way they see the world, is made difficult to say the least. In the current climate, when much of the energy of teaching work must be directed at the standardised, measurable, test-driven, reductive and inflexible curriculum, care for what students individually value is given even less opportunity.

Brett values the cultural and social values of each student. He is grounded in acceptance of all forms of popular culture and youth identity. Difference and disparity, stylised and personal characteristics are regarded as unique individual traits and not as anything unusual or as an anomaly. His concerns for the plight of youth, over and above any need to mould them into any specific tradition or template, grew from early experience with youth centres:

> I came straight out of a degree and then went straight into state schools, did 16 years in Queensland and then when I was teaching down in Logan, there was nothing around the local community for kids so I got together with a few mates and we kicked off a drop-in centre. And then that snow-balled from just pool tables and X-Boxes and stuff like that, to "Let's do some training programs".

Brett's ideas for the behavioural management of young people are more akin to the notions of "giving space" and "letting be" rather than "making fit". In the MIC community, students are encouraged towards basic principles of care and ethical behaviour:

> We just take the rules away and we go, "There are four pillars: Trust, Respect, Community and Participation" – that's it.

At the centre of the school is relational trust,[53] which is important for young people to feel like they are valued and respected as individuals. Indeed, the students we spoke with often referred to a lack of trust in their previous school contexts, contrasting them with the open trust that is conferred at MIC. Brett continues on this theme:

> They get trust from the word go from us, we unlock everything in the building. I would have no hesitation throwing most of the kids at our school the keys to the building and the security code. The only ones I wouldn't are the ones that probably couldn't remember the code and

would probably forget to lock up - they're the only kids I probably wouldn't give the keys to. No guitars have been stolen, no amps have been stolen, nothing's been stolen. No cameras, nothing. You're talking, you know, fifteen to eighteen-year-old kids from every background, as diverse as you can imagine, kids with lots of money to kids with no money at all; nothing. That's a completely different mindset to any other school I've been at; you lock everything down, you do not open anything. No one gets a key; staff don't even get bloody keys.

In contrast, MIC starts from a position of trusting both the staff and students, which we think is demonstrated by the following accounts from teachers at the school. The removal of restrictions on freedom of movement, expression and participation do much to reduce the motivation for people to want to bend or break the rules. This is shown in the following comment by Kristin, the mathematics teacher:

> I think once the kids knew here that we actually trusted them they stopped playing a lot of games that they'd been playing at their previous schools.

This point is also evident from the experience of James, the film and television teacher, who says:

> We have fewer rules, which means in a way we have less ways of getting them in trouble, you know. I think sometimes schools, and partly because they're so enormous, they have really strict rules because they have to try and keep them in line. Whereas we don't need to worry about that quite as much; we can relate to students on a personal level.

Charlie is a musician and English teacher. His current hip-hop band, The Winnie Coopers, populates YouTube with raps of injustice and the need for "keeping it real". He started playing in bands during high school and continued to do so through teachers' college. After graduating, his journey through different teaching positions provided a range of contrasting experiences. This commenced with a private school on the Gold Coast, teaching drama and English. He then:

> Sort of got a bit disillusioned with the whole education versus business model that they were running there and moved to Sydney to play in another band

It was in Sydney that he became engaged and married before deciding to move back to the Gold Coast and to a position in another private school

over the border in northern New South Wales. His new rap band per-
formed at a few venues and festivals around town, and it was there that
he met Brett who was organising some music events, benefits and fund-
raisers. In addition to booking bands, Brett was running The Spot youth
centre and he recruited Charlie to help with the new education programs
planned for Year 10 students who had been marginalised and excluded
from mainstream schools. While running programs at the Spot, Charlie
also taught at two different low socio-economic, culturally diverse state
schools.

> I was still doing my music, and then I got a text out of the blue from
> Brett, saying "I'm starting a school. Are you interested to come and be a
> part of Music Industry College?" So it's been a bit of a journey.

Importantly, Charlie is able to retain a personal musical identity as an
artist in the context of his teaching. One does not preclude the other.
Similarly, Kristin is also a musician. She tells us:

> I started playing in a sort of alternative punky Brisbane band back in '89,
> '90. And then I was in an all-girl band for a little while, sort of more inde-
> pendent alternative stuff, and then I wound up in a three-piece surf band
> playing bass which I'd never played in a band before. And just yeah, just I
> guess these days just enjoying playing parties more so than anything, it just
> seems to fit in a bit better and I have a hell of a lot of fun. But I still really
> enjoy writing songs.

Being connected to music and the music industry is an important pre-
requisite for working at MIC. Kristin continues:

> I have a love of music outside of teaching, like having played in bands over
> a long time, this job seemed to be the perfect marriage of a love and an
> interest outside of work with what I was doing at work for all this time.

Charles is a music teacher and also a long-time guitar stalwart on the
Brisbane band scene. He says:

> I enjoy using my music industry experience in my everyday teaching,
> which I wasn't able to do as much at my previous school. I have a lot of
> respect from the students because of my music industry experience.

Charles also tells us:

> We have a more individual approach to the students and their educational challenged; we've got a very small staff so we're able to adjust the things that we do to cater for the individual students or at least to engage the individual students probably more strongly than is practical at a larger school.

Ed is a singer-songwriter and the Business teacher at MIC. He tells us about the school:

> The students are given a lot of autonomy, you know. Basically they can dress in any way they want to; they can dye their hair any colour they want to; they can sign out if they don't feel like they're going to do well today.

Brett elaborates on the sign-out process for us:

> Yeah, well there's a sign-out book. The only punishment for signing out at any time during the day is we send a text to your parents with exactly the reason you write down on the sign-out sheet. That's the only punishment, there's no "You have to make up that time", if you don't feel like being here you sign out. So we had one kid once - a good story - he wrote in "Couldn't be fucked", that's why he signed out. So we texted to whoever "Signed out 'he couldn't be fucked'". Parent texted back "Did they seriously?"I'm like, "We just tell you what they write down in the book"."I'll have words with him when he gets home". Next day the kid's "Why did you send that?!'" I was like "You wrote it down. Reason for leaving: 'Couldn't be fucked'. So you wrote it down". And that's the only punishment. And like I said to that young man, I basically said, "That's the consequence of your actions. I'm not going to cover for you, you've got to grow up and face your parents and go 'I couldn't be fucked being at school'". But that's indicative of the attendance, is they literally don't have to be here unless their parents are forcing them to be here. We don't, so "There's the sign-out book, go. See you tomorrow".

We ask Blair, a former Film and Television teacher at MIC, to describe what is different about teaching here?

> Flexibility. Little things like starting at 10 o'clock rather than starting at 8 o'clock. Students are up until midnight or later on social media or half these kids are mentoring bands or running club nights and things like that as well. Some are working at Maccas until 9 o'clock, 10 o'clock at night, so being

able to get on the bus at nine instead of seven or something like that definitely helps them. Little things like no dress code, they can all let their own attitude and style out about who they want to be. There is none of this sort of conformity. With rules and behavioural management, I've never had to discipline a student. I've never had to use any type of behaviour modification technique here. They come in. They understand that they're in a place where it's about learning. We let them run with style and their own individuality.

We get parents who have come and they've seen the student finish after a year and they're in tears because they've seen their kids get back into learning and get back into education and the apathy towards education at the end of grade 10 or nine or whatever has completely gone. They're here and they're thriving. It's incredible.

Kristin says about teaching at the school:

> It's fantastic. For lots of different reasons. It's great being part of a really small staff, and it's great being part of a really small school. And with that comes a whole sense of family and everybody knows everybody else, and with that comes a real sense of caring. Yeah so when we have staff meetings we're able to talk face-to-face with everybody who's involved and we're able to mention kids by name and get to the bottom of a lot of the issues rather than feeling that we're lost in a massive staff and the kids are lost in a massive school.

When asked about what he thinks works at the school, James tells us that there are two main things that set MIC apart from more conventional schools:

> One is the size of the school, and because it's a small school of about seventy to eighty students it kind of works differently to a school where you might get lost in the kind of bureaucratic sense. So I think that works. Students help each other out, students and teachers work together in different projects outside of class as well as inside of class, and we have smaller class sizes which I think is really important, and is much easier to deal with than when I taught at the private schools and the government schools. So I think that's one thing. And the other thing is that we, as much as we can, use the music industry as a way of teaching curriculum. So, you know, teaching what the government wants to be in the curriculum as well as what we think should be in there.

The comments by James highlight the tensions of navigating curriculum mandates while still adhering to the particular philosophical and pedagogical focus of the school. This curriculum tightrope-walking is not

uncommon in schools, although it is particularly pronounced here.MIC manages to inoculate itself against what Jensen and Walker[54] refer to as "curriculum management disease". This, they describe is the curriculum planning rationale that assumes that pupils and teachers "are only being properly directed when pushed or pulled by some external forces, by extrinsic motivation".

Similarly, Kristin talks about the curriculum at MIC and the freedom given to staff to work collaboratively and with professional autonomy:

> Well, one great thing that Brett does is he gives us a lot of autonomy with our subjects. But he doesn't cut us adrift, he's always checking in on how we're going and he's always there to sound ideas off all the time. So I've really respected that he's respected us enough to go ahead and create our courses and run our classes and run with extra-curricular ideas that we've come up with. So he has a lot of trust in us and that's one of the pillars of the school, and when that trust is there you feel like you've got permission to give things a try and you feel like you've got the backing of your Principal. And I haven't always felt that in other schools that I've worked at. I always feel like Brett's got our back, yeah. And if he doesn't always agree then he's happy to say why, but he always hears you out which is lovely

This is supported by Brett's comments:

> Teachers get frustrated and teachers get burnt out, because they see they don't have a choice. Staff love the fact they're given freedom here. I never walk into any teacher and go, "You have to teach this". What I do is, "You're the expert in that content area; you write your own work program how you see fit, how you want to run the subject". Why should I interfere?

We ask Ed to tell us what makes the school unique:

> We set aside all the politics and ass-kissing, all that sort of stuff isn't what it's about. It's just about getting great work done and getting the students the best results they can. And that's really key, that's the sort of place I need to work.

Teachers are given the opportunity to pursue their professional growth in multiple ways. For example, Brett tells us:

> I think the other thing that we do differently from my experience is very proactive on teacher training and professional development, and when I

was a teacher if you heard 'professional development' I would cringe because it meant I'm going to a lecture about something that I'm not interested in that's going to have no impact on me as a teacher but the principal thinks it's important for all of us to go to that, and a lot of it would be on how to control student behaviour. I rarely have a problem with kid behaviour. I've always had that ability to get on with teenagers, yet other teachers have a kid at the principal's door, well send them to that professional training, not me. Whereas here we let the staff choose what PD they want to do and then when we can afford it we pay for that, we send them off to that and I think it's important that everyone continues to learn, not just the students.

Charlie says to us:

> I am reminded of a professional development day I went to early on for MIC teachers and one of the workshops was 'Getting past "No" in the workplace'. And I remember sitting around a table with other teachers just saying 'No one's told me "No" at MIC', because Brett's philosophy is if you're passionate about it and you're going to run it then it's going to be successful and the kids are going to be attracted to that as well. So I really respond to that sort of environment where I'm given license to pursue what I'm interested in.

We'd like to finish the chapter with an extract from an interview with Brett, which goes some way to demonstrating how the politics and philosophy connect deeply with pedagogy to help give teachers the freedom to teach.:

> What worries you most about education?
>
> Government. That's a simple one. Kids are incredibly intelligent, incredibly talented and skilled, and we treat them like they know nothing. And we force feed them stuff that we think is important, or someone thinks is important. They're in a system at five years of age, thirteen years of schooling now before they have a choice. Don't get me started. I get on the soap box and I rant for hours.
>
> So what does get you up every day, coming in?
>
> I started it, I've got a responsibility. That's the kind of stark reality. Some days that's, you know, what gets me here. Most days is because I just love seeing young people's potential realised, that's if you're looking for the honest answer I've worked with young people since I was twenty-one years of age and I just love seeing that young person, who may not believe in

themselves, transform into this young person who believes in themselves and goes 'I can do this'. And it may not be, you know, they're the ones getting played on Triple J or played at the Opera House or whatever, but the fact that that kid just now believes in themselves enough to have a crack and have a go. And I think we need more and more of that. We need more adults to believe in young people and not bag the crap out of them. Like the media's been doing it for a couple of hundred years, we still bag young people. Because they're an easy target, they don't vote, they don't really have a voice. So we just bag the shit out of them every opportunity we get. But we've locked them up for thirteen years.

What would you say would be your biggest pleasure this year?

Always seeing the work that the kids produce. And not just work in the classroom, in actual fact the stuff that pleases me the most is what they actually produce just artistically. And I think that comes out of the culture of the school where they're given a license to do that. You saw it at lunch time,[55] you know, they can be creative and expressive and no-one's yelling at them to stop being stupid. There's not a teacher in there on playground duty going "Don't do that!" and I think that comes out of that culture of you've got the freedom to be yourself. And I think that's every year, just the sheer delight I get from hearing a new song or watching a performance or seeing a piece of art and going "One of our kids, a sixteen or seventeen-year old, produced that. That's amazing".

NOTES

1. Smyth (2012). In addition, see Jensen and Walker (2008, p. 69). Compton and Weiner (2008), document the global assault on teachers, teaching and unions. Connell (2009) discusses the changing perceptions of "good teaching" in the light of new regulation and reform.
2. See Apple (2004). He states, "Education is one more product in the neoliberal, essential view that the world is a vast supermarket", p. 32.
3. Francis and Mills (2012, p. 260).
4. Smyth (2011, p. 54).
5. Connell (1985, p. 69).
6. Connell (2009).
7. McGregor and Mills (2014).
8. Noddings (2013, p. 152).
9. Smyth (2011, p. 14).
10. Lingard (2005, p. 169).
11. See discussion, Burnard and White (2008, p. 674).

12. Mockler and Groundwater-Smith (2014, p. 29). NB, their use of italics is retained.
13. Ball (2003, p. 215).
14. Ball (2006, p. 154).
15. Ball (2003, p. 218).
16. Connell (2009, p. 218). Connell also points out how "auditable competencies can become the whole rationale of a teacher education programme".
17. Connell (2009, p. 220), discusses, the "narrowing of practice", standards documents and teacher registration regimes.
18. Smyth (2006b, p. 286).
19. Thomson et al. (2012, p. 4). See also Riddle and Cleaver (2015b).
20. Giroux (1988, p. xxxiv).
21. Lingard (2005, p. 166).
22. Lingard and Mills (2007, p. 235).
23. McLaren (2007).
24. Giroux (2005, p. 74).
25. Connell (1985, p. 70).
26. McLaren (1995, p. 232).
27. Jensen and Walker (2008, p. 148). They discuss the "regulatory technologies for ensuring that teachers conform to the efforts of modernization of education" and also "the ideological shift in which the managers of public services come to dominate the mission and strategies through organisational discourse...".
28. Apple and Beane (2007, p. 20).
29. Noddings (2003, 2013).
30. Held (2006).
31. We argue for this in Riddle and Cleaver (2015a, b).
32. Lingard and Keddie (2013).
33. Biesta (2017).
34. Giroux (2005).
35. Giroux (2005, p. 112).
36. Giroux (2005), p. 20).
37. We discuss this in more detail in Chap. 5, where we examine the cultural and community life of the school.
38. Hayes et al. (2006).
39. See: Hayes et al. (2006), Lingard (2005, 2007), Lingard and Mills (2007).
40. Lingard and Keddie (2013, p. 443).
41. Lingard and Mills (2007, p. 237).
42. Hayes et al. (2006, p. 7).
43. Delpit (2006).

44. See Riddle and Cleaver (2013).
45. See Riddle and Cleaver (2015b).
46. McLaren (2007, p. 51) discusses the need for *praxis-orientated pedagogy* at "street level", where educators are critically reflective while unifying theory and practice (as *praxis*).
47. For example, see: Day (2005), Riddle and Cleaver (2013).
48. Smyth et al. (2014, p. 137).
49. Ball (2006, p. 147).
50. See Riddle and Cleaver (2013).
51. Mills and McGregor (2014).
52. Noddings (1984, p. 67). We acknowledge Barone (2001, p. 136) for this quote. Barone is using it to describe Don Forrister, who is a caring teacher in ways that we recognise in Brett.
53. Smyth (2012).
54. Jensen and Walker (2008).
55. See Chap. 1, where we describe a day in the life at MIC.

REFERENCES

Apple, M.W. 2004. *Ideology and curriculum*, 3rd ed. New York, NY: Routledge.

Apple, M.W., and J.A. Beane. 2007. *Democratic schools: Lessons in powerful education*. Portsmouth: Heinemann.

Ball, S.J. 2003. The teacher's soul and the terrors of performativity. *Journal of Education Policy* 18 (2): 215–228.

Ball, S.J. 2006. *Education policy and social class: The selected works of Stephen J. Ball*. Abingdon, Oxon: Routledge.

Barone, T. 2001. *Touching eternity: The enduring outcomes of education*. New York: Teachers College Press.

Biesta, G. 2017. Don't be fooled by ignorant schoolmasters: On the role of the teacher in emancipatory education. *Policy Futures in Education* 15 (1): 1–22. doi:10.1177/1478210316681202.

Burnard, P., and J. White. 2008. Creativity and performativity: Counterpoints in British and Australian education. *British Educational Research Journal* 34 (5): 667–682.

Compton, M.F., and L. Weiner. (eds.). 2008. *The global assault on teaching, teachers, and their unions: Stories for resistance*. New York, N.Y: Palgrave Macmillan.

Connell, R.W. 1985. *Teachers' work*. Crows Nest: Allen & Unwin.

Connell, R.W. 2009. Good teachers on dangerous grounds: Otwards a new view of teacher quality and professionalism. *Critical Studies in Education* 50 (3): 213–229.

Day, C. 2005. Principals who sustain success: Making a difference in schools in challenging circumstances. *International Journal of Leadership in Education* 8 (4): 273–290. doi:10.1080/13603120500330485.

Delpit, L. 2006. *Other people's children: Cultural conflict in the classroom.* New York, NY: The New Press.

Francis, B., and M. Mills. 2012. Schools as damaging organisations: Instigating a dialogue concerning alternative models of schooling. *Pedagogy, Culture & Society* 20 (2): 251–271. doi:10.1080/14681366.2012.688765.

Giroux, H.A. 1988. *Teachers as intellectuals: Toward a critical pedagogy of learning.* Granby, MA: Bergin & Garvey.

Giroux, H.A. 2005. *Border crossings: Cultural workers and the politics of education,* 2nd ed. New York, NY: Routledge.

Hayes, D., M. Mills, P. Christie, and B. Lingard. 2006. *Teachers and schooling making a difference: Productive pedagogies, assessment and performance.* Crows Nest: Allen & Unwin.

Held, V. 2006. *The ethics of care: Personal, political, and global.* Oxford: Oxford University Press.

Jensen, K., and S. Walker. 2008. *Education, democracy and discourse.* Michigan, MI: Bloomsbury Academic.

Lingard, B. 2005. Socially just pedagogies in changing times. *International Studies in Sociology of Education* 15 (2): 165–186. doi:10.1080/09620210500200138.

Lingard, B. 2007. Pedagogies of indifference. *International Journal of Inclusive Education* 11 (3): 245–266. doi:10.1080/13603110701237498.

Lingard, B., and A. Keddie. 2013. Redistribution, recognition and representation: Working against pedagogies of indifference. *Pedagogy, Culture & Society* 21 (3): 427–447. doi:10.1080/14681366.2013.809373.

Lingard, B., and M. Mills. 2007. Pedagogies making a difference: Issues of social justice and inclusion. *International Journal of Inclusive Education* 11 (3): 233–244. doi:10.1080/13603110701237472.

McGregor, G., and M. Mills. 2014. Teaching in the 'margins': Rekindling a passion for teaching. *British Journal of Sociology of Education* 35 (1): 1–18. doi:10.1080/01425692.2012.740813.

McLaren, P. 1995. *Critical pedagogy and predatory culture: Oppositional policies in a postmodern era.* London: Routledge.

McLaren, P. 2007. *Life in schools: An introduction to critical pedagogy in the foundations of education.* Boston, MA: Pearson.

Mills, M., and G. McGregor. 2014. *Re-engaging young people in education: Learning from alternative schools.* Abingdon: Routledge.

Mockler, N., and S. Groundwater-Smith. 2014. *Engaging with student voice in research, education and community: Beyond legitimation and guardianship.* Dordrecht: Springer.

Noddings, N. 1984. *Caring: A feminine approach to ethics and moral education*. Los Angeles, CA: University of California Press.

Noddings, N. 2003. Is teaching a practice? *Journal of Philosophy of Education* 37 (2): 241–251. doi:10.1111/1467-9752.00323.

Noddings, N. 2013. *Education and democracy in the 21st century*. New York: Teachers College Press.

Riddle, S., and D. Cleaver. 2013. One school principal's journey from the mainstream to the alternative. *International Journal of Leadership in Education* 16 (3): 367–378. doi:10.1080/13603124.2012.732243.

Riddle, S., and D. Cleaver. 2015a. Speaking back to the mainstream from the margins: Lessons from one boutique senior secondary school. In *Mainstreams, margins and the spaces in-between: New possibilities for education research*, ed. K. Trimmer, A. Black, and S. Riddle, 170–182. Abingdon: Routledge.

Riddle, S., and D. Cleaver. 2015b. Working within and against the grain of policy in an alternative school. *Discourse: Studies in the Cultural Politics of Education*. doi:10.1080/01596306.2015.1105790.

Smyth, J. 2006. When students have power': Student engagement, student voice, and the possibilities for school reform around 'dropping out' of school. *International Journal of Leadership in Education* 9 (4): 285–298. doi:10.1080/13603120600894232.

Smyth, J. 2011. *Critical pedagogy for social justice*. New York, NY: Continuum.

Smyth, J. 2012. Problematising teachers' work in dangerous times. In *Critical voices in teacher education*, ed. J. Smyth and B. Down, 13–25. Dordrecht: Springer.

Smyth, J., B. Down, and P. McInerney. 2014. *The socially just school: Making space for youth to speak back*. Dordrecht: Springer.

Thomson, P., B. Lingard, and T. Wrigley. 2012. Reimagining school change: The necessity and reasons for hope. In *Changing schools: Alternative ways to make a world of difference*, ed. T. Wrigley, P. Thomson, and B. Lingard, 1–14. London: Routledge.

Community, Culture and Connections in Alternative Schooling

We are different coloured feathers but we are all on the same bird.
Student comment in a focus group
This one goes out to those fixated with green and spend their time counting their beans
And it seems that all of us are just fiends who have different goals and share different dreams
But you won't find joy in a packet of pay
there's a void in your life 'cause you're created that way
I guess it depends on how you measure success
The Winnie Coopers, Charlie's hip-hop band

Abstract This chapter takes a broader view of the school community and tracks the paths of previous students who are now 'out in the world', as well as connecting with parents, school staff, and other community members who have been closely integrated into the school's wider community. Key vignettes illustrate the importance of connecting to community and the development of a rich school culture, which is an essential component of socially-just schooling.

Keywords Community · Mainstream · Alternative · Connectedness · Relationships · Social justice

© The Author(s) 2017
S. Riddle and D. Cleaver, *Alternative Schooling, Social Justice and Marginalised Students*, Palgrave Studies in Alternative Education, DOI 10.1007/978-3-319-58990-9_5

In this chapter, we broaden our picture of the MIC community to include the experiences of previous students who are now "out in the world", as well as parents and other community members who are connected to the school, alongside the perspectives of current students and teachers. In Chap. 2, we described the positive community vibe at MIC and here we continue with a critical discussion that stresses the importance of "school connectivity" and an inclusive school community and culture. Our illuminations highlight affective matters that are relevant to well-being in the school community, to the value of a connected curriculum and also to the extension of the school community to the world beyond.

Our engagement with MIC has opened us to broader issues related to making schools into places that are more "hospitable to the lives, interests, backgrounds and aspirations of young people"[1], and our inquiry has led us to the contributions to well-being offered by a positive culture of community and connectedness. In order to discover how the lives of students can be institutionally organised in ways that contribute to their well-being, we seek to "trouble" and disrupt the status quo concerning current practices and organisational policies that "systematically prevent and preclude the development of community among students and that directly contribute to students' experience of isolation, alienation and polarisation", and we contest "beliefs and practices that nurture individualism and competition, rather than community and collaboration"[2] in the culture of our schools.

Perspectives and comments shared by MIC students, some presented earlier in Chap. 3, have exposed issues with inhospitable atmospheres in previous mainstream schools and also demonstrated how the cohesive community at MIC has contributed to getting them motivated and learning. As with many studies investigating alternative schooling sites, we found that at MIC there is a strong sense of school being a safe space that fosters a strong sense of community and belonging. The physical, emotional and psychological safety creates a kind of sanctuary[3] where the students are no longer alienated or struggling at the margins. For this chapter, we include vignettes and accounts of experience about the satisfaction in belonging to a positive community and discuss what this produces in terms of reimagining the project of schooling from a perspective of social justice.

We are aware of the complexities surrounding our points for discussion, especially as "community" is a contested notion and one that

both opens up and closes spaces for engaging with others. For example, Johnson suggests that community is "always fragile and fractured, always takes variable forms and always involves particular kinds of power. It includes, embraces and empowers, but it also excludes"[4]. In the light of these paradoxes and complexities, we note those aspects of the MIC community that are wholesome rather than fractured are inclusive and embracing rather that exclusionary, and also governed by the kind of power that is fair and democratic. We agree with Smyth[5] who argues for engaged communities that are relational, inclusive, participative, connected, socially just and sustainable.

With MIC, a relational, inclusive community spirit comes built-in from the start and is easily sustained as it specifically targets students and teachers with shared interests. Music is the glue that unifies and creates inclusion.[6] Kristin, the maths teacher, reminds us that:

Music ties the whole school together, and once you've sparked that interest you've

really got them.

In considering affective and relational components, an important unifying factor is a common, underlying objective where most MIC students are seeking a second (third or fourth) chance and we sense that many, despite personal issues, challenges and tensions, deep down really do want to participate in schooling. We note how the students are comforted within the MIC community. As Roffey explains, belonging to a community is a psychological need and a sense of well-being is achieved through connection through shared values and interdependence with others in an inclusive school community. She states, "people have a powerful, negative, deep-rooted reaction to being socially rejected" and it is critical to well-being to feel socially and emotionally connected[7]. Many of the students who talked to us had described personal stories of discovery of a new, social and emotional connectedness.

In their book, *Dropping Out*, Smyth and Hattam[8] argue that working with early school-leavers provides useful insights into why young people disconnect from their schooling. They suggest some potential strategies for connecting schooling more effectively to the lives of young people, including minimising interactive trouble; reshaping curriculum and pedagogy to be more inclusive; transforming school cultures; and reframing

the credentialising processes of schooling. All of these suggestions fit with the notion of changing schooling to better fit young people, rather than the other way round.

A complexity in transforming school culture to one of connectedness is determined to a large extent by adapting and fitting the school to the very nature of adolescence. Young people's lives are characterised by the formation of a mix of drives and emotions that may manifest as opposing tensions. On the one hand, there is the discovery of individuality, independence and often a desire to be "different" as personal ego and self-identity unfold. Yet on the other hand, there is belongingness, the need to connect with others, to find shared values and place within a group. In the poetically expressed awareness of a MIC student, this amounts to individuality, being a *different coloured feather*, and belongingness, being located *on the same bird*.

Equality and social justice manifest in the ways that MIC connects to the individual lives of each student while maintaining a commitment to making sure all students fit in toa welcoming, inclusive community culture. On the other hand, we cannot help but be concerned how, in contrast, exclusion and alienation in mainstream, contemporary schools come built-in. Many of these unresolved complexities in the mainstream are compounded by the exclusionary, anti-democratic mechanisms that "have a serious impact on social relations in schools, the relations between school leaders and teachers and between teachers and students".[9] We would agree that "Teachers, parents and students need to discuss openly how schools could work as social and learning communities rather than as knowledge factories or bureaucratic organisations", and "it is time to examine what schools might do to create a sense of stability and belonging".[10] MIC is certainly warm and welcoming; the following statement by Brett presents a contrasting situation for students who had once felt alienated, switched off and marginalised in mainstream schools:

I'm really pleased that the kids want to be here. We kick them out on the holidays; we kick them out on Friday afternoons because they just want to stick around. I mean they work here on a Saturday night running a venue, and to me that's really gratifying and rewarding in that – Because education is for the students, not for me.

The physical size, number of students and teachers at MIC are the factors that contribute to the ease in which the inclusive MIC community has developed. Some students had described feeling lost within a large cohort at their previous school. Riley, a Year 11 student, contrasted her feelings now at MIC:

> We're all like a big family. And we get a lot of one-on-one time with the teachers to help us with our struggles with school, maybe like our personal life, whereas at my old school that wasn't available at all.

We asked James, the film and television teacher, what he thought the school provided for students who weren't seeking to work in the music industry. He provided a range of insights into the flexibility of MIC and also the factor of its size:

> Well one of the things is that it's a small community, which means that we can work with students a lot easier. We provide flexibility in that the way that the whole school is set up, it's less sort of structured; we don't have set rows in each classroom, now we have purpose-designed rooms for different subjects. And this means that it's not a traditional school, which many students had struggled with. They've either had so many problems going on at home or they don't really fit or then they might be a really quiet student. I can mention student who's quite capable but she just didn't really fit in with the huge school that she was at before and she can cope much better in a smaller school; she gets attention from her teachers in terms of if she has an assignment it's much easier for a teacher to help her out. There are some students who yeah they have special circumstances and we're able to work around that. I guess one of the philosophies behind it was how Brett saw in traditional schooling how some students just slipped through the cracks.

Diversity and plurality[11] sit at the heart of a democratic community, where schools are sites of connection and belonging. Charles, a music teacher, alludes to the diversity of students while also describing the effects of being in a small school:

> We have a mix of some students who would probably have done very well at a traditional school and are really interested to come to MIC because they have extra interest in the music industry and they are strong performers and want to develop that, and then we have other students who don't

feel like they fit in so well at other schools and perhaps they were being bullied or they didn't likesome aspects of the culture of the school. I really can't speak for them, but perhaps they feel because of the size of the school we have a very community-oriented sort of approach; everyone knows everyone's name, there's not really any issues with bullying, we try to approach the students where we treat them more like adults and infantilise them as little as possible, and have almost a sort of tertiary campus atmosphere.

We consider how schooling can contribute more to social justice, and with concern for the "radically reshaped common-sense of society"[12] bought on by reforms that divert critical pedagogy away from its task of social transformation to pedagogy of compliance set with rules and regulations that only seek to serve competitive, market and economic ends. Australia, once considered "the lucky country" with "a fair go for all" is fraught with complicated problems like "cyclical poverty and social disadvantage, the absolute neglect of indigenous peoples, the growing gap between rich and poor and the contribution of policy structures strongly influenced by neoliberal fundamentalism"[13]. We are concerned that the mechanisms of advantage, which we discuss at some length in Chap. 6, have the effect of creating gated academic compounds in some places, while ghettoising others, and also encouraging a situation where elite private schools eclipse their public counterparts. We are also concerned about the effect this has on young people, the modelling of social justice, insensitivity through privilege and advantage and the fostering of a spirit and atmosphere that culturally and socially separates and disconnects from local community and the "real world" beyond.[14] To the extent that Francis and Mills can state, "to observe that schools reproduce social inequality is by no means novel"[15], warrants the need for persistent critical questioning, review and public reflection on how much educational privilege and elitism contribute to insensitivity towards equality and social justice in our schools.

Schooling as "preparation for the real world" is a commonly used phrase and for us it echoes the function of education that relates to developing resilience, creativity, adaptability and social skills for the realities that young people will face.

David's interjection: I reflect back on how 'unreal' my boarding school life was - like a simulated reality, a little kingdom of academic learning, sheltered, exclusive, isolated and disconnected from 'ordinary life' and

ordinary matters. Features such as resilience,flexibility and adaptation had to be discovered afterwards, 'out of school'. An ordered sheltered and regimented life was the antithesis of creativity and offered nothing about being streetwise. My father had complained about many of the same issues after manyyears served in the army.

We note those isolating, alienating and protecting features of contemporary school life that separate it from the real world. From an MIC parent, we hear of an irony where a mainstream school is described as inadvertently protecting her daughter from the mainstream world:

Yes, I think (MIC) has introduced her to more of the mainstream world. She's not as protected as she was at the girls' school where we dropped her off in the morning and picked her up because we weren't sort of near the public transport for us, so it was a little bit more of a protected environment there. So now her catching the train and going to Fortitude Valley, and she has developed independence and she's a bit more streetwise with travelling on the trains and walking around and mixing with all these different students from different backgrounds.

Elsewhere, we have discussed curriculum connectedness and how a feature of alternative schools is a life-rich curriculum that connects to the individual and collective interests of the students[16]. This aspect of connectedness "indicates both a respect for students' knowledges and interests and the need to scaffold learners into other knowledge forms, genres and media from which disadvantaged students should never be excluded"[17]. We observe how MIC promotes curriculum connectedness, in addition to music being the connecting thread, through tailored activities that involve real-world applications and community learning. Kristin offers some further insights into how curriculum connectedness works at MIC:

I've got a lot of freedom to line up what I do with the music industry and what the kids' interests are. We go through the same processes that kids in another school would do, like learning how to tabulate and graph and analyse the data, but it's all within a music industry context.

Kristin tells us more about linking mathematics to music:

I used to get the old "When are we ever going to use this?" question many times a day. And there are some topics that that was very hard to answer.

But here, I'd say nine times out of ten that's just not issue because, say for the statistics assignment for example, they can see how that scenario would then influence promoters and organisers about how they then plan their next festival, what changes next year. Another assignment that we do here is tax, and they look at it not just as a dry old tax assignment; it's doing a musician's tax return for them and getting them to see what a musician should be looking out for to claim and reduce the tax they have to pay and giving them advice as to how to manage their finances in general. So you can see the little light bulbs going off saying, "Oh, so when I do this... I can keep that receipt and...", that kind of thing.

The realities of working and making a living in the industry are authentically presented to students. Brett offers a detailed narrative of the thinking behind authentic engagement:

We had our art exhibition last night and one of the things that we tried to do this year, we did all of this last year but we did it all in house, on campus. We've made a commitment this year to take stuff into a real venue, a real facility so we took the art exhibition to an art gallery. We hung the pictures off wires, on a white background and in a proper gallery and we had wine and cheese and made it a proper art evening and it was very impressive. The kids work was outstanding and surprising how much better it looks when you take it into a gallery. It looks like it belongs there. When you've got it at school, it looks like it. Not that it doesn't look as good but it just feels like something is not right here and that was just a fantastic evening and the feedback from that has been fantastic, from parents, from students and we had people from outside the school come as well. Next week we have our musical, which will be at Metro Arts Theatre, so again it's in a theatre so again it heightens that experience for the students. It rewards them, it's like this is good enough to be shown here and the videos of the musical has been shot in full HD so we're going to show it in Blu Ray in full HD and in a theatre and two sessions have sold out already. We've got a third session, so that's been encouraging and then the week after that is our awards and graduation evening. So last year that was a massive highlight and we had feedback from parents and grandparents and friends of kids. The thing that we got back from that last year, we've got to make sure we maintain this year, is how much kid friendly it was. You go to some schools' awards evenings and they get up the front and say okay, I'd just like to tell everyone before we start, no catcalling, no whistling, keep your applause until we've awarded everybody, we give one round of applause at the end, it's like it's stuffy and there's yes, bravo, you

know. Our awards night the kids were whooping and hollering and cheering and one mother came up to me and her son had transferred from, I won't say the school, but a very prestigious private school in Brisbane, and she said that if this had of happened at my son's last school, all these students would be suspended. She said how wonderful it was for kids to be able to be kids and that's what we try and do. It's their night, it's their celebration, it's not about me and I think sometimes I'll refer to my experience in larger schools, those nights become about the institution and the corporation and they stop being about the students and I think it's really disappointing and we've tried to make everything we do, with that stuff, about the students and it's their night to celebrate and within reason, obviously, they weren't the wines drinking the wine last night, it was the parents and the guests but it was their night and we had music performances in one back room of the gallery and the students hung all the art during the day and they ran the night pretty much. They set it up, they packed it up, they emceed it. Students will emcee our graduation. I'll speak at the beginning, that's it, everything else will be student run, student delivered and I don't even read their speech beforehand to make sure that it's kosher because we trust the kids.

Smyth, Down and McInerney, among their listed set of principles and elements for discussion and debate about community oriented and socially engaged schooling, identify the importance of respectful relationships, trust and goodwill and that students should feel a strong sense of identity, belonging and acceptance[18]. Gabrielle, a student who had described her previous private school as "strict" and where "the uniforms were like pink and you had to have ribbons in your hair, you couldn't have loose bits hanging out, like not even a fringe" and "it was academic everywhere", responded positively when asked about her feelings of trust while now at MIC:

Here, it's just like if you come in and you're upset or something, like your peers will come around and they will help you out, and they will basically become your family. And then although it's like a small community it's a really good small community because we can get along with everyone.

Many MIC graduates remain part of the extended community and a number of past students emailed us describing how they regularly return to the school through a desire to remain connected, to meet and talk with current students. This takes place through self-volition and not through any officially organised alumni program or association that

requires stimulation or coerced recruitment. This point relates to the hospitable co-operation modelled by the school where students "develop in fellowship and work together" on an equal footing to create a positive community[19]. First, Gabrielle describes this; her perspective is as a current student and reveals how it works positively:

> Oh yeah, yeah, we've seen so many people from, like last year's year twelves who graduated, so many of them have been coming in and we've all been like really happy to see them. And that's also leading like to the community, you meet them and then you're like 'Okay, I like this person' and then you're like 'Oh they're coming in, oh I'm so excited' and it makes you happy, and then it makes them feel welcomed to come back.

James, a MIC graduate, emailed us to describe his success since leaving but also found time to include a comment about returning to the college as part of the community and to also offer time and service:

> I've had work experience at Channel 9 and 612 ABC, I've filmed my own TV show, ran my own radio show, produced numerous videos and have built up my confidence which has basically eradicated my anxiety. I've had the opportunity to film a promotional video for MIC and am continually in contact with my past teachers, visiting the school and helping out when I can. Some of my best friends are my fellow students I met while finishing my school studies at MIC and probably will be for the rest of my life.

We were interested to meet with as many parents as time would allow in order to discover their perspectives, feelings and thoughts about MIC. We saw this as an important part of our broad picture and understanding of the school community. It was deeply moving to be invited into hearing how those, agreeing to participate and give up time to be interviewed, were engaged in the intricacies of parenting and resolving difficult situations. Parental love, compassion and unconditional support were evident, where the desire was often more for children to be fulfilled, to be themselves and to find paths to happy futures than getting an education for a job. A number of participating parents had what might be described as progressive views about education and they harboured empathetic understanding of the issues about schooling. We asked Selly's[20] father if he had any reservations about her attendance at MIC. His patience and understanding of his daughter, together with a humorous use of metaphor, was a feature of Selly's father's response:

The only apprehension we had was that it was a music industry college and she was really into art. But she drove the whole thing, found out about the school and applied for the interview. But really we've always seen her right from birth as a free-spirited brumby that you'd let run wild but just keep her corralled when she needed, you know, if she went too wild bring her back into the paddock, settle her down and then let her out again until she hit the next wall or fence and then we'd guide her and then she expands herself.

Anne was also very happy to talk about her son, who had been excluded from his mainstream school due to the personal issues exacerbated by a mental health condition. When discussing what to do about the matter of being excluded from school, Anne said:

We were sort of like well there's not much point sending him to another state school because we're going to come up against the same philosophies and structures that had caused us so much concern where he was.

However, when the topic of the negativity of a one-size-fits-all education arose, Anne responded:

I was just going to say we've always searched for non-mainstream schooling for our boys, and we did that I New Zealand and over here as well. So it's something I'm very passionate about. For precisely that reason - that one size doesn't fit all - and my aim in choosing schools throughout has been to maintain... to allow my kids to maintain who they are, rather than get moulded into what a school thinks they should be. So it's a pretty fundamental philosophy for me.

Another parent did express a more resigned note, stating:

Well, as a parent it wasn't the education that I wanted for her, it's not the line that we've been going down since she started school, and it's taking us a while to come to terms with it. But we can see that, you know, the most important thing is that she's happy and healthy and that, you know, she's enjoying herself. And that's just what we focus on.

Blair, a former MIC teacher, who had declared to us that "it's a bit more of a family and community than a school", shared the following when discussing the parents and their role in their children's reconnection to schooling:

We get people like the parents who have come and they've seen the student finish after a year and they're in tears because they've seen their kids get back into learning and get back into education and the apathy towards education at the end of grade 10 or nine or whatever has completely gone. They're here and they're thriving. It's incredible.

Kristin reports on how much of the reputation of MIC is being transferred through family understanding and their respect for how it works:

We've had a few families come through, like you know, big sister comes then little sister comes through. With the first child there's a bit of a fear, like, 'What are we doing? What is this school? Is this a wise decision? Not really sure, very new, very different. And then they get here and it's... for the vast majority who took the chance they're very happy, and the happy parents get up and speak at our open days and our fundraising nights. And the breadth of the support that we get from our fundraisers is incredible, so we feel very well supported. I will never forget when a parent said, "This school saved my son's life, you know? My son was very depressed and if it wasn't for MIC I don't know if we'd still have him because he just literally did not fit in".

While we have offered much about the students and teachers at MIC, it is important to include the business of school operation and an administrator who is placed at the heart of it. An important relationship exists between Brett and the MIC business manager, Ros. She equally "took on the passion of MIC" and supported Brett right from the outset when the school was just a dream. For every step of the project, where Brett did the dreaming, Ros has been engaged, contributing with practical decisions, helping bring his dreams into fruition. She tells us:

It is no easy task keeping up with his dreams.

In addition to keeping the books and organising events, Ros does everything from project managing events including the herculean move to the new campus building in Fortitude Valley, designing the colour scheme and the furniture ("Nothing is in my job description"). On weekends, Ros can be found working with Brett moving furniture for an event. They make a very effective team, especially as husband and wife and with the process of raising their own kids during the setting up of the drop-in centre (the Spot) and also MIC. Between having children, Ros worked in other jobs:

But always got drawn back to the dream becausethat's what I've found, like, this only works because of both of us.

Together, they share their concerns, with care and compassion about the marginalised, the dropouts, the bullies in schools, Asperger's, ADHD, communicating and getting through to students, the freedom to be adults, connecting with parents (including holding parties for the parents) and an education that works for each and every young person who they take into the school community. Importantly, passion and energy for justice, along with the social and emotional welfare of young people ensures that Brett and Ros refuse to become hamstrung or stymied by limitations imposed by bureaucracy, or by what Jensen and Walker call the "rather frightening part" of modernisation of education and public service, and "the dominating discourses of private enterprise, the core issues that actually *exclude* democratisation and instead legitimate decision-making processes that, through the notion of authoritarian leadership and hierarchical organization systems, serve to alienate most of those working in the domain"[21]. Recognising that "the value of education should not be assessed solely in terms of economic efficiency and social welfare"[22], Brett and Ros jump through hoops to make MIC work.

Before moving on to a consideration of the broader implications for schooling and social justice, we would like to leave this chapter with a short excerpt from a former student's narrative. We feel that this story can be understood as a kind of summary for the care and sensitivity that many mainstream schools could learn from if they are to seriously consider ways to retain students, and for an approach to national and global education policies that really do seek to improve dropout rates:

How did Brett support us? He treated us like adults. It didn't feel like we were rocking up to a school to be disciplined and to be chastised and he basically gave us a choice and it kind of prepared me for university as well. And it was weird coming from a school where I was being sent home for having hair too long, where he was like, "Look, I don't care about uniform.I don't care about your appearance, as long as it's, you know, respectable. But you're here to learn and we're all adults here". He kind of treated us like an equal, and it was that kind of realisation that kicked it off in my head that, you know, like it kind of just developed my skills and made me more mature as well.

Finally, our argument here is that the development of a common good through a commitment to community and culture is essentially about a renegotiation and critical reflection on basic principles and values. Connecting young people to their communities provides enormous opportunities to forge lasting bonds and shared understanding of what schooling should be for, rather than allowing education to continue to be dominated by what Charlie's band. The Winnie Coopers describe as *those fixated with green and who spend their time counting their beans*. For a world imbued with economic objectives, capitalisation and corporatisation of education and all social life, *I guess it depends on how you measure success*[23].

NOTES

1. Smyth (2011, p. 56).
2. Osterman, (2000, p. 324).
3. See O'Gorman et al. 2016, for a systematic review of contextual factors and student retention in alternative education. They coin the notion of alternative schools as "sanctuaries".
4. Johnson (2009, p. 5).
5. Smyth (2011).
6. Cleaver and Riddle (2014).
7. Roffey (2011, p. 16).
8. Smyth and Hattam (2004).
9. Jensen and Walker (2008), pp. 2-3.
10. Wrigley (2006, p. 66).
11. Fielding and Moss, (2011).
12. Apple (2008, p. 247).
13. Graham (2007, p. 4).. See also Kenaway, 2013, for a critique of inequality in Australian schools and how issues have not been addressed (Kenway 2013).
14. Australians are polarised on this point. As an example, recently, Australia was embroiled in a culturally sensitive issue where a group of young Australian men at the Malaysian Grand Prix had stripped down to swimwear emblazoned with the Malaysian flag, were arrested. International relations were compromised and they narrowly escaped conviction The public outcry that ensued in the media focused on the exclusive private, schooling of each offender, suggesting that this had rendered them as "white, privileged and culturally insensitive". Young students themselves are polarised. A furor erupted in the media when a student from an elite Jesuit College posted a taunt on Facebook to "povos" (poverty stricken

public school kids) saying, "Remember to say hi to me when I am your boss". For further discussion, see http://www.essentialkids.com.au/education/school/high-school/kids-behaving-badly-20160311-gngjfl.

15. Francis & Mills (2012, p.254).
16. Riddle & Cleaver (2013). We had quoted Yuginovich & O'Brien (2009), who elaborate on this point.
17. Wrigley et al. (2012, p. 99).
18. Smyth et al. (2014, p. 88).
19. Jensen and Walker (2008. p.36).
20. See Chap. 3 for an extended account of Selly's experiences at MIC.
21. Jensen & Walker, (2008. p.2).
22. Rawls, (1999, p. 17).
23. Thanks goes to Charlie for giving us permission to use some of the lyrics from his work with *The Winnie Coopers*. We found a strong political, moral and ethical alignment between what Charlie writes and rhymes about in his artistic mode, and the living of those commitments as a teacher at MIC.

REFERENCES

Apple, M. W. 2008. Can schooling contribute to a more just society? *Education, Citizenship and Social Justice.* 3 (3): 239–261.

Baroutsis, A., G. McGregor, and M. Mills. 2016. Pedagogic voice: Student voice in teaching and engagement pedagogies. *Pedagogy, Culture & Society* 24 (1): 123–140. doi:10.1080/14681366.2015.1087044.

Cleaver, D., and S. Riddle. 2014. Music as engaging, educational matrix: Exploring the case of marginalised students attending an 'alternative' music industry school. *Research Studies in Music Education* 36 (2): 245–256. doi:10.1177/1321103X14556572.

Fielding, M., and P. Moss. 2011. *Radical education and the common school: A democratic alternative.* Abingdon: Routledge.

Francis, B., and M. Mills. 2012. Schools as damaging organisations: Instigating a dialogue concerning alternative models of schooling. *Pedagogy, Culture and Society.* 20 (2): 251–271. doi:10.1080/14681366.2012.688765.

Graham, L. 2007. (Neo)Liberal doses of inequality: Advance Australia where? In *Creativity, enterprise and policy-new directions in education*, ed. R. Shaw. Wellington: Philosophy of Education Society of Australasia.

Jensen, K., and S. Walker. 2008. *Education, democracy and discourse.* Michigan, MI: Bloomsbury Academic.

Johnson, R. 2009. Introduction. No easy answers: Jeremy Brent, southmead and "community". In *Searching for community: Representation, power and action on an urban estate*, ed. J. Brent, 1–10. Bristol: Policy Press.

Kenway, J. 2013. Challenging inequality in Australian schools: Gonski and beyond. *Discourse: Studies in the Cultural Politics of Education* 34 (2): 286–308. doi:10.1080/01596306.2013.770254.

Kraftl, P. 2013. *Geographies of alternative education: Diverse learning spaces for children and young people*. Bristol: Policy Press.

Lingard, B., and A. Keddie. 2013. Redistribution, recognition and representation: Working against pedagogies of indifference. *Pedagogy, Culture & Society* 21 (3): 427–447. doi:10.1080/14681366.2013.809373.

McGregor, G., and M. Mills. 2014. Teaching in the 'margins': Rekindling a passion for teaching. *British Journal of Sociology of Education* 35 (1): 1–18. doi:1 0.1080/01425692.2012.740813.

McLaren, P. 1995. *Critical pedagogy and predatory culture: Oppositional policies in a postmodern era*. London: Routledge.

Mills, M., G. McGregor, A. Baroutsis, K. te Riele, and D. Hayes. 2015. Alternative education and social justice: Considering issues of affective and contributive justice. *Critical Studies in Education*. doi:10.1080/17508487.2 016.1087413.

O'Gorman, E., N. Salmon, and C.A. Murphy. 2016. Schools as sanctuaries: A systematic review of contextual factors which contribute to student retention in alternative education. *International Journal of Inclusive Education* 20 (5): 536–551. doi:10.1080/13603116.2015.1095251.

Osterman, K. 2000. Students need for belonging in the school community. *Review of Educational Research*. 70 (3): 323–367.

Rawls, J. 1999. *A theory of justice (revised edition)*. Cambridge, MA: Harvard University Press.

Riddle, S., and D. Cleaver. 2013. One school principal's journey from the mainstream to the alternative. *International Journal of Leadership in Education* 16 (3): 367–378. doi:10.1080/13603124.2012.732243.

Roffey, S. 2011. Enhancing connectedness in Australian children and young people. *Asian Journal of Counselling*. 18 (1&2): 15–39. Retrieved from http://www.circlesolutionsnetwork.com/wp-content/uploads/2014/03/8-2011-Roffey-Enhancing-Connectedness.pdf.

Rowe, F., and D. Stewart. 2009. Promoting connectedness through whole-school approaches: A qualitative study. *Health Education* 109 (5): 396–413.

Smyth, J. 2011. *Critical pedagogy for social justice*. New York, NY: Continuum.

Smyth, J., B. Down, and P. McInerney. 2014. *The socially just school: Making space for youth to speak back*. Dordrecht: Springer.

Smyth, J., and R. Hattam. 2004. *Dropping off, drifting off, being excluded: Becoming somebody without school*. New York, NY: Peter Lang.

Te Riele, K., M. Mills, G. McGregor, and A. Baroutsis. 2017. Exploring the affective dimension of teachers' work in alternative school settings. *Teaching Education* 28 (1): 56–71. doi:10.1080/10476210.2016.1238064.

Wrigley, T. 2006. *Another school is possible*. London: Bookmarks Publications.
Wrigley, T., B. Lingard, and P. Thomson. 2012. Pedagogies of transformation: Keeping hope alive in troubled times. *Critical Studies in Education* 53 (1): 95–108. doi:10.1080/17508487.2011.637570.
Youdell, D. 2011. *School trouble: Identity, power and politics in education*. Abingdon: Routledge.
Yuginovich, T., and P. O'Brien. 2009. Staff perceptions of an alternative educational model for at risk adolescents in Queensland. *The International Journal of Interdisciplinary Social Sciences* 3 (12): 15–26.

CHAPTER 6

On Social Justice and Schooling

We keep sacking good kids from schools.
Brett, principal
If you don't want to be here, leave; but no one leaves.
Student

Abstract This chapter draws together the perspectives presented in this book and revisits the themes of social justice established in Chap. 1, in order to provide some salient lessons for mainstream schooling that might be re-imagined for social justice in the interests of those most disadvantaged. It shares some final thoughts that illustrate the importance of inclusive and democratic schooling for all young people and considers how the policies, philosophies and practices of Music Industry College might be taken up and realised in other educational contexts.

Keywords Democratic education · Schooling · Marginalisation Disadvantage · Students · Social justice

Throughout this book, we have shown MIC to be a school built on what we consider to be the core principles of social justice: redistribution, recognition and representation.[1] Working with Fraser's conception of social justice, we are inclined to agree with Mills and colleagues that schooling

© The Author(s) 2017
S. Riddle and D. Cleaver, *Alternative Schooling, Social Justice and Marginalised Students*, Palgrave Studies in Alternative Education, DOI 10.1007/978-3-319-58990-9_6

111

needs to take into account the "issues of distribution, or the economic injustices faced by the young people attending the schools; issues of recognition, that is, the cultural injustices faced by these young people; and issues of representation, with regard to the political injustices"[2] that young people encounter in a system that does not currently serve their interests. Yet, as they argue, this is not enough as it does not account fully for the affective dimensions, which is why the notion of care and relationships is so important in the project of education for social justice, and which we have detailed in previous chapters.

These principles of social justice are demonstrated at MIC through the commitment to providing access to meaningful educational opportunities for young people (redistribution), while acknowledging that students bring their own capacities, individual desires, subjectivities and struggles to schooling (recognition), and through parity of participation in the demos of the school, allowing students' voices to be heard and taken seriously at all levels of the school's organisational, cultural and academic life (representation). We agree with Keddie[3] that these principles should be at the heart of any attempt to reorder schooling in more socially just ways.

At the same time, we should be clear: schools like MIC do not provide a panacea for the educational, and indeed broader social trouble that young people encounter. In a perfect world, public education would be able to honour its mission to provide access to high-quality education for all young people, regardless of their backgrounds, interests and capacities. Yet the world we live in is far from perfect. As we argued in Chap. 2, market-based policy decisions by governments of various persuasions over the past thirty or more years in Australia have, with breathtaking success, undermined the very notion of the public,[4] recrafting it as collective individualism, where everyone getting what they individually want becomes the measure of the public good.

In his biting critique of contemporary Capitalist economies, Rancière[5] describes how the political, social and economic are collapsed into an *equality of conditions* that produces mass individualism in the self-interested pursuit of limitless growth. The question of the public good is collapsed into getting the most you can out of your situation, without concern for others, as they are likely to be doing the same thing. We reject this as being either public or good as we believe that such a Hobbesian take on the social contract as a compact between peoples should not be the measure of a collective social enterprise, whether we

are talking education or otherwise. The social, and in fact the very plane-tary, condition means that we need a collective commitment to the pub-lic more than ever before.

What we see happening instead is the atomisation of the public, which produces the hyper-individualising consumer, who above all else, is free to make choices within specific markets that cater to their needs and desires. In education, one example of this is evidenced through the mantra of school choice and the argument that parents should be able to send their children to the very best school in town. It seems self-evident on the first presentation, because what parent wouldn't want the best for their children? In fact, MIC itself is largely able to exist with the con-temporary schooling quasi-market because of the existence of choice. However, we feel that there are a number of serious concerns about school choice that need to be considered, given how they work in ways that run counter to improving social justice outcomes for all young peo-ple, especially those who are left without the option to choose an alter-native, because they have become marginalised and excluded from access to high-quality schooling.

First, the argument that parents have a choice in what schools they want to send their children to is, for many parents simply not true. For families living in poverty or in communities of high levels of disadvan-tage, with unemployment, health and other welfare concerns, there is simply no capacity to choose. For others, living in regional or remote parts of Australia, the choice is extremely limited. The levels of choice afforded to middle-class families living in inner-city centres are vastly dif-ferent to others, who do not have the same levels of economic or cultural capital available to them.

Second, we need to acknowledge that in many instances, when par-ents are making choices about schooling, they are actually choosing to buy into advantage, rather than specifically seeking a school that best suits the needs of their child. One clear effect of this buying into advan-tage is the increasing segregation of Australian schooling, which can be seen in the concentration both of advantage in some schools and areas, with concentrated disadvantage in others. The high level of school seg-regation is a significant issue in Australia, because it tends "to reinforce patterns of inequality and strengthen differences in school performance. This means that students from disadvantaged SES backgrounds tend to do worse because of the extent of segregation".[6]

Finally on the question of choice and alternatives, we agree with Savage[7] that the market-based argument of school choice produces an effect of actually entrenching the mainstream in education, where there is little difference between public and non-government schools in areas of high advantage, because in an effort to compete in the market, what they essentially provide is neither different nor alternative. Importantly, this is for us where MIC is different and provides a truly radical alternative that goes beyond simple choice in a market. While it does tap into the discourse of choice, it offers an alternative for young people and one that is substantially different to the choice to attend a wealthy private school versus the public school down the road.

Further to these concerns, we understand that "not all alternative schools support marginalised students or are concerned with matters of social justice. However, in many instances, alternative schools have emerged out of an attempt to support the educational needs of young people who have not been served well by "mainstream" schooling".[8] The way we see it is that it becomes less about the notion of choice of schools and more about reconstructing schooling itself, so that the local public school *is* the best option for young people to have a meaningful, connected and authentic educational experience.

We believe that now "is time for a re-imagining of what schools could be"[9] and that the project of remaking schooling in the interests of those who are currently least advantaged[10] has never been more important. As the stories shared by students (Chap. 3), teachers (Chap. 4) and parents (Chap. 5) clearly show, the importance of connecting young people to a culture and community of learning, such as that provided by MIC, is critical for the project of addressing marginalisation and disenfranchisement. If the goal is for an education that promotes both equity and excellence,[11] it is imperative for us to acknowledge the important role of social advantage and the impacts of disadvantage on social justice efforts. As Kenway argues, "social advantage currently equates with educational success and social disadvantaged currently equates with educational failure. Clearly, claims to the contrary should be put to rest".[12] We couldn't agree more.

In his book, *Wasted Lives*, Bauman[13] describes how particular groups of people become produced as "human waste"—refugees, migrants, unemployed and people living below the poverty line—as a necessary condition for Capitalist societies. We would argue that many young people in Australia would be discarded, socially, economically and politically,

if it weren't for schools like MIC. This is a wicked problem, given that we believe in a strong and robust public education system. It is simply unacceptable to allow public schooling to abrogate its responsibility to all young people by allowing some to become educational waste or by-products of a system that only permits one version of success. It disgusts us, but we agree with the argument that "the justification for the extent and the depth of the damage inflicted upon particular groups of young people (and the institution of schooling), always collapses back to the argument that these reforms have been necessary in the national economic interest".[14] Perhaps it is time to start living in a society, rather than an economy.

We wonder, what might happen if we were to upend the policy fixation on education as primarily serving an economic function, and instead consider all our policy-making and educational practices from a social justice perspective? What if we were to take up Connell's[15] call to reconstitute schooling in the interests of those least advantaged, rather than continuing to produce curriculum and assessment practices that overwhelmingly favour those already in positions of extraordinary privilege? We think that it is worth at least trying, because the status quo is evidently not working for many young people.

Francis and colleagues[16] describe how discourses of social justice in education are not without contradictions and the formation of unhelpful binaries. It is not our intent to fall into the trap of an emancipatory politics of education, where social justice is about *saving* young people from themselves or from the social, economic, political and material circumstances they find themselves in. This would be to take up an ideological position that is all too easily captured by the flows of capitalism and neoliberal education policy-making, itself developed from a social justice position. We are not certain that a flag-waving commitment to progressive critical pedagogy will bring forth the kind of social justice outcomes that we need in our schools, given the great setbacks that progressive education has faced in recent times.

Perhaps what is needed is a different kind of response to the damaging effects of contemporary market-based approaches to schools inflicted on young people in communities that are subjected to a constant onslaught of neoconservative and neoliberal policies[17] from governments that seem to care more about providing tax cuts to large multinational corporations ("the benefits will trickle down to all") than a healthy, educated and engaged public. Without doubt, "a plethora of institutional practices

work to generate and reproduce inequalities in ways that are not easy to counter".[18] Hayes and colleagues make a really powerful point, when they say:

> Inequalities are normalised in discourses of schooling in a number of ways: they are naturalised so that their social constructions lips from view; they are individualised so that their social patterns are not acknowledged; their meanings are settled so that change seems impossible; alternatives are so idealised in utopian visions that what is achievable becomes devalued. Speaking against the normalisation of inequalities is an ethical and political move with which we engage as we work with and against these discourses to address what we have identified as the central challenge for teachers, administrators and other educators: how to make sure that schools are places of learning, so that learning is one of the effects of schooling.[19]

While it may be the case that in its current form, "education is central to the modern *legitimation* of inequality",[20] we believe that it does not need to be this way. MIC provides an example of how the redistributive potential of education might work to disrupt simple reproductions of social hierarchies and social identities. The notion of education as reproduction[21] sees schools as sites of legitimation of social inequality. Instead, we agree with Youdell, who sees schools as having the potential to be "important sites of counter or radical-politics".[22] However, at the same time, we are cautious about the possibility of radical politics, given the constraints of schooling, and social engagement more generally. We love the ideal, but wonder what it might look like it practice.

Much has been made of the emancipatory potential of education, or what Freire[23] describes as education being a practice of freedom. However, we have an uncomfortable relationship with the argument that education is in itself emancipatory. Take, for example, the following argument presented by Biesta,[24] that "although emancipation is aimed at liberation of the one to be emancipated, it actually installs dependency at the very heart of the act of emancipation. After all, the one to be emancipated is dependent upon a 'powerful intervention' by the emancipator". He argues that the logic of emancipation requires "distrust in the experiences of the one to be emancipated, suggesting that we cannot really trust what we see or feel but need someone else to tell us what is really going on".

From our vantage, it seems that trusting the young people at MIC is exactly why it works. So can we then say that Brett and his colleagues are undertaking a project of emancipation, or does that simply fall into the distrust trap described above by Biesta? We don't think so. In fact, we would suggest that there is a deliberate removal of the powerful–powerless binary at MIC, not so that students may "become free", but that they can engage in a democratic politics that taps into the particular individual and collective needs of the community. We think that MIC is a democratic school and that it demonstrates the kind of democracy that needs to be defended, as Apple argues, "the defence of democracy, and its expansion into important aspects of our lives, is quite important both substantively and strategically".[25]

Of course, there is also an uncomfortable tension with the notion of democracy in the classroom, given that schools by their very design are intentionally undemocratic social institutions. By this, we mean that schools are places where young people learn to regulate and control their behaviours, to follow rules and engage in a multitude of compliances to authority. Rancière[26] argues that young students are "representative par excellence of democratic humanity" but that such democratic individualism is actually the enemy of the contemporary form of democratic society, which he equates to limitless mass individualism. Fielding and Moss[27] call for a radically utopian vision of democratic education, where schools become sites of community building and civic participation, rather than simply producing future workers for a global market. Given these arguments and debates, we think that it is a defensible position to claim that MIC is a good example of democratic education at work.

Giroux argues that "schools should provide students with possibilities for linking knowledge and social responsibility to the imperatives of a substantive democracy".[28] Therefore, a socially just curriculum[29] must be at the heart of any social justice schooling project. In order to pursue a wider social justice agenda in education, we agree that there is an urgent need to attend to "hierarchies of knowledge and to the organisation and delivery of education through contemporary schooling practices".[30]

Young[31] argues for powerful knowledge underpinning curriculum as a vehicle for social justice. No doubt it is an interesting position, one that seeks to reclaim knowledge-based curriculum as opening up access and opportunity for marginalised and disenfranchised students. We are not so sure that powerful knowledge itself is key, but knowledge that is contextualised, situated and meaningful. In this regard, we take the notion of

funds of knowledge as described by Zipin and colleagues,[32] where cur-
riculum sits within communities and is expressed as powerful through
the agency that arises from its use. At the same time, we also agree that
"social justice demands that students are not excluded from conventional
knowledge through the artificial division between academic and non-
academic knowledge (and students) but rather have access to a common
curriculum".[33] It is not enough to simply deliver either a mainstream or
a marginal curriculum. We need both.[34]

On social justice and schooling, Connell argues that "education is a
social process in which the 'how much' cannot be separated from the
'what'. There is an inescapable link between distribution and content".[35]
It is not enough to prosecute equity of access to education without also
addressing the uneven distribution of knowledge, cultural capital and its
relationship to economic benefits. In order to shape a redistributive jus-
tice, we need to understand that students are not equitably positioned
to take up the material, cultural or social benefits from schooling.[36] Yet,
it seems to us that the whole-scale school reform agenda in Australia
and elsewhere, with an emphasis on efficiency and accountability, simply
maintain traditional practices and "do not meet the needs of individuals,
communities or nations".[37]

In a counter-response to the current trajectory of schooling in
Australia, we think that MIC offers a radically hopeful narrative[38] of how
schooling might employ counter-hegemonic alternatives that "reinstill a
sense of imaginative possibility".[39] In this, we take up Smyth and col-
leagues'[40] call for the *socially just school*, committed to engaging young
people in a meaningful education that connects to their lives, aspira-
tions and communities. Within the socially just school, students are seen
as being capable and full of promise, rather than simply being at risk.
The socially just school works in deliberately counter-hegemonic ways to
reframe school in the interests of those who are most disadvantaged.[41] At
the very heart of this is the question of knowledge and how it becomes
accessed and produced in classrooms.

As Lingard describes, "we need to acknowledge the weave between
identity negotiation and the production and reproduction of knowl-
edge in the pedagogical encounter and its effects".[42] In other words,
the argument that schools are simply places where knowledge is pro-
vided to young people ignores the importance of the relational spaces
that are formed through the acts of teachers and students. Along with
McLaren, we would argue that "how students, teachers, and others

define themselves and name experience is a central pedagogical concern because it helps educators understand how classroom meaning is produced, legitimated, or delegitimated".[43]

We are concerned with the delegitimating effects of schooling-as-usual, without regard for the particular situated lives and knowledge of young people themselves. To simply enact a curriculum of power does not address the systemic and social disadvantage that many young people face. At the same time, we agree with Biesta, who claims that "we also need a robust and thoughtful account of the specific character of education which needs to go beyond the fashionable but nonetheless problematic idea that education is about learning and that teaching is about the facilitation of learning".[44] While we can easily say that at MIC the students learn and the teachers do a good job of teaching, for us what is most important is the work that happens alongside the formal, enacted curriculum. It is the formation of community, of culture, of connectedness, that is so potent for marginalised and disenfranchised young people. We argue that this is a form of what Connell calls *curricular justice*,[45] which positions young people as democratic participants in democratic schooling, addressing the interests of those who are least advantaged by the system, and is purposefully counter-hegemonic.

Perhaps what is needed is a new form of critical pedagogy, which we argue is provided at MIC through the connected curriculum that taps meaningfully into the lives, aspirations, concerns and interests of students. Giroux makes the case in the following way:

> Critical educators cannot be content to merely map how ideologies are inscribed in the various relations of schooling, whether they be the curriculum, forms of school organization, or in teacher-student relations. A more viable critical pedagogy needs to go beyond these concerns by analysing how ideologies are actually taken up in the contradictory voices and lived experiences of students as they give meaning to the dreams, desires, and subject positions that they inhabit. Critical educators need to provide the conditions for students to speak differently so that their narratives can be affirmed and engaged critically.[46]

We consider Productive Pedagogies[47] as one possible model of pedagogy that works in counter-hegemonic and critical ways to re-engage young people in a meaningful education. It is a model that takes up social justice in generative ways. Lingard and Keddie describe it as a model that

seeks to "strengthen schooling as a good in its own right, as well as in positionalterms (redistribution), work with and value cultural difference (recognition), and accord students a voice (representation)".[48] The four dimensions embed a politics of social justice: Intellectual Quality, Connectedness, Supportiveness, and Valuing and Working with Difference.[49] However, we also acknowledge that pedagogy on its own will never be up to the task, given its complex relationship with curriculum and with the sociality of schooling. We are convinced that it does play an important role in the mix of a counter-hegemonic approach to schooling.

As we have shown in this book through the stories shared by students, teachers and parents at MIC, there is a need for schooling that connects with the lives of young people in substantial and sustained ways. There is a need for schooling that goes beyond the daily practices of classrooms as spaces of knowledge transfer, acquisition and production. There is a need for schooling that starts from the margins and reconstructs the mainstream.

However, it is important to note that we have known for a long time that "schools can influence, but alone cannot determine, educational outcomes".[50] Schools, after all, exist within communities that have a complex set of social, political, economic and cultural conditions that impact on the lives of people within those communities. While we agree that "clearly, schools cannot fix the existing inequalities and injustices of a society. However, they can respond to the consequences that flow from them. This of course requires an investment of money and material goods sufficient to the task".[51] So the question then becomes one of what the resourcing is and how it is to be provided. But these are good questions to ask, because it opens up the conversation for a more socially just schooling, not just for students at schools like MIC, for but all students everywhere. We agree with Smyth, Down and McInerney who state:

> We do not wish to give the impression that the current state of affairs in politics and education is not without hope, far from it. As we show in this book another kind of school is possible[52] – a socially just school based on the principles and values of critical inquiry, social justice, democracy, compassion, care and respect. In pursuing these pedagogical ideals we take a stand against the top-down and authoritarian approaches proffered by our political leaders and their allies in order to present an alternative socially critical pedagogy of teaching that signposts a way forward.[53]

As Keddie[54] explains, we need to constantly examine what educational equity and socially just approaches to schooling might look like in contemporary times, given the strong demand for socially just schooling. It is not enough to say, "Look at MIC. Don't they do a great job of connecting young people with meaningful learning that supports them intellectually, socially, and emotionally?" While this might make us feel good and make for some interesting reading of particular accounts of lives in the school, we need to do more.

Observed from the margins and considered in light of the mainstream, MIC can be considered 'alternative'. However, when viewed, not from the margins but from an educational ideology where social justice and democracy are not compromised by corporate, competitive, standardised and instrumentalist agendas, MIC is a school that is quite normal. For us, the larger project is about making schools like MIC the new normal. The challenge is how to take these lessons and use them in ways that help to reconstitute mainstream education to be more normal. By that, we mean more socially just, more democratic, more radically engaging, more participatory, more liveable.

We think that society would be better served by more normal schools like MIC. In such a situation, schools like MIC would become completely unremarkable. We would love it if schooling was at a point where a book like this one was made redundant. Given the enormous complexities and challenges of our time, we owe it to young people of all persuasions, to have the very best chance of a meaningful education that can be provided. Business as usual simply won't work. We need to radically reconfigure schooling. And we need to do it now.

Notes

1. See Fraser (1997, 2010, 2013) for an account of her developing threefold approach to justice as redistribution, recognition, and representation. While we do not suggest that this is a perfect model, the consideration of the social, cultural and political is important when faced with accounts of equity as the prevalent myth of economic access in a meritocracy (Ball 2008).
2. Mills et al. (2015, p. 1).
3. Keddie (2012).
4. Gerrard et al. (2017) for an interesting discussion of the shifting *public* in contemporary Australian education.

5. Rancière (2006).
6. Lamb et al. (2015, p. 69).
7. Savage (2013).
8. Mills et al. (2015, p. 151).
9. Mills and McGregor (2014, p. 134).
10. Connell (1993).
11. MCEETYA (2008).
12. Kenway (2013, p. 306).
13. Bauman (2004).
14. Smyth et al. (2014, p. 2).
15. Connell (1993).
16. Francis et al. (2017).
17. See Apple (2006, 2013) for a scathing critique of the market and inequality in education, as well as a more hopeful vision of what schooling might be.
18. Hayes et al. (2006, p. 8).
19. Hayes et al. (2006, p. 210).
20. Connell (1993, p. 27).
21. Bourdieu and Passeron (1990).
22. Youdell (2011, p. 1).
23. Freire (1972).
24. Biesta (2017, p. 4).
25. Apple (2012, p. 155).
26. Rancière (2006, p. 26).
27. Fielding and Moss (2011).
28. Giroux (2003, p. 9).
29. Zipin (2015).
30. Francis et al. (2017, p. 4).
31. Young (2013).
32. Zipin et al. (2012).
33. Smyth et al. (2014, p. 61).
34. Zipin (2015) gives a really good account of how this curriculum of the powerful and the marginalised might be realised.
35. Connell (1992, p. 136).
36. Keddie (2012, p. 266).
37. Wrigley et al. (2012, p. 97).
38. See Smyth et al. (2014) for a discussion of radical hope in schooling, also see Fielding and Moss (2011), Giroux (1997).
39. Apple (2012, p. 157).
40. Smyth et al. (2014).
41. Connell (1993).
42. Lingard (2007, p. 246).

43. McLaren (2007, p. 244).
44. Biesta (2015, p. 84).
45. Connell (1992).
46. Giroux (2005, p. 24).
47. Hayes et al. (2006).
48. Lingard and Keddie (2013, p. 428).
49. Lingard and Keddie (2013, p. 442).
50. Karmel et al. (1973, p. 23).
51. Mills and McGregor (2014, p. 274).
52. Wrigley (2006), also gives a good account about how "another school is possible".
53. Smyth et al. (2014, p. 94).
54. Keddie (2012, p. 277).

REFERENCES

Apple, M.W. 2006. *Educating the "right" way: Markets, standards, god and inequality*, 2nd ed. New York: Routledge.
Apple, M.W. 2012. *Education and power*. New York: Routledge.
Apple, M.W. 2013. *Can education change society?* New York: Routledge.
Ball, S.J. 2008. *The education debate*. Bristol: Policy Press.
Bauman, Z. 2004. *Wasted lives: Modernity and its outcasts*. Cambridge: Polity Press.
Biesta, G. 2015. What is education for? On good education, teacher judgement and educational professionalism. *European Journal of Education* 50 (1): 75–87. doi:10.1111/ejed.12109.
Biesta, G. 2017. Don't be fooled by ignorant schoolmasters: On the role of the teacher in emancipatory education. *Policy Futures in Education* : 1–22. doi:10.1177/1478210316681202.
Bourdieu, P., and J.C Passeron. 1990. *Reproduction in education, society and culture*, trans. R. Nice. London: Sage.
Connell, R.W. 1992. Citizenship, social justice and curriculum. *International Studies in Sociology of Education* 2 (2): 133–146. doi:10.1080/0962021920020202.
Connell, R.W. 1993. *Schools and social justice*. Toronto: Our Schools Ourselves Education.
Fielding, M., and P. Moss. 2011. *Radical education and the common school: A democratic alternative*. Abingdon: Routledge.
Francis, B., M. Mills, and R. Lupton. 2017. Towards social justice in education: Contradictions and dilemmas. *Journal of Education Policy* 32: 1–18. doi:10.1080/02680939.2016.1276218.
Fraser, N. 1997. *Justice interruptus: Critical reflections on the "postsocialist" condition*. New York: Routledge.

Fraser, N. 2010. *Scales of justice: Reimagining political space in a globalizing world*. New York: Columbia University Press.

Fraser, N. 2013. *Fortunes of feminism: From state-managed Capitalism to neoliberal crisis*. London: Verso.

Freire, P. 1972. *Pedagogy of the oppressed*, trans. M. B. Ramos. Hammondsworth, Middlesex: Penguin Books Ltd.

Gerrard, J., G.C. Savage, and K. O'Connor. 2017. Searching for the public: School funding and shifting meanings of 'the public' in Australian education. *Journal of Education Policy* 32: 1–17. doi:10.1080/02680939.2016.1274787.

Giroux, H.A. 1997. *Pedagogy and the politics of hope: Theory, culture and schooling*. Boulder, CO: Westview Press.

Giroux, H.A. 2003. Public pedagogy and the politics of resistance: Notes on a critical theory of educational struggle. *Educational Philosophy and Theory* 35 (1): 5–16. doi:10.1111/1469-5812.00002.

Giroux, H.A. 2005. *Border crossings: Cultural workers and the politics of education*, 2nd ed. New York: Routledge.

Hayes, D., M. Mills, P. Christie, and B. Lingard. 2006. *Teachers and schooling making a difference: Productive Pedagogies, assessment and performance*. Crows Nest: Allen & Unwin.

Karmel, P., J. Blackburn, G. Hancock, E.T. Jackson, A.W. Jones, G.M. Martin, and W.A. White. 1973. *Schools in Australia: Report of the interim committee for the Australian schools commission*. Canberra: Australian Government Publishing Services.

Keddie, A. 2012. Schooling and social justice through the lenses of Nancy Fraser. *Critical Studies in Education* 53 (3): 263–279. doi:10.1080/17508487.2012.709185.

Kenway, J. 2013. Challenging inequality in Australian schools: Gonski and beyond. *Discourse: Studies in the Cultural Politics of Education* 34 (2): 286–308. doi:10.1080/01596306.2013.770254.

Lamb, S., J. Jackson, A. Waltstab, and S. Huo. 2015. *Educational opportunity in Australia 2015: Who succeeds and who misses out*. Melbourne: Centre for International Research on Education Systems, Mitchell Institute.

Lingard, B. 2007. Pedagogies of indifference. *International Journal of Inclusive Education* 11 (3): 245–266. doi:10.1080/13603110701237498.

Lingard, B., and A. Keddie. 2013. Redistribution, recognition and representation: Working against pedagogies of indifference. *Pedagogy, Culture & Society* 21 (3): 427–447. doi:10.1080/14681366.2013.809373.

MCEETYA. 2008. *Melbourne declaration on educational goals for young Australians*. Melbourne: Ministerial Council on Education, Employment, Training and Youth Affairs.

McLaren, P. 2007. *Life in schools: An introduction to critical pedagogy in the foundations of education*. Boston, MA: Pearson.

Mills, M., and G. McGregor. 2014. *Re-engaging young people in education: Learning from alternative schools.* Abingdon: Routledge.

Mills, M., G. McGregor, A. Baroutsis, K. te Riele, and D. Hayes. 2015. Alternative education and social justice: Considering issues of affective and contributive justice. *Critical Studies in Education.* doi:10.1080/17508487.2016.1087413.

Rancière, J. 2006. *Hatred of democracy.* London: Verso.

Savage, G. 2013. Tailored equities in the education market: Flexible policies and practices. *Discourse: Studies in the Cultural Politics of Education* 34 (2): 185–201. doi:10.1080/01596306.2013.770246.

Smyth, J., B. Down, and P. McInerney. 2014. *The socially just school: Making space for youth to speak back.* Dordrecht: Springer.

Wrigley, T. 2006. *Another school is possible.* London: Bookmarks Publications.

Wrigley, T., B. Lingard, and P. Thomson. 2012. Pedagogies of transformation: Keeping hope alive in troubled times. *Critical Studies in Education* 53 (1): 95–108. doi:10.1080/17508487.2011.637570.

Youdell, D. 2011. *School trouble: Identity, power and politics in education.* Abingdon: Routledge.

Young, M. 2013. Powerful knowledge: An analytically useful concept or just a 'sexy sounding term'? A response to John Beck's 'powerful knowledge, esoteric knowledge, curriculum knowledge'. *Cambridge Journal of Education* 43 (2): 195–198. doi:10.1080/0305764X.2013.776356.

Zipin, L. 2015. Chasing curricular justice: How complex ethical vexations of redistributing cultural capital bring dialectics to the door of aporia. *Southern African Review of Education* 21 (2): 91–109.

Zipin, L., S. Sellar, and R. Hattam. 2012. Countering and exceeding 'capital': A 'funds of knowledge' approach to re-imagining community. *Discourse: Studies in the Cultural Politics of Education* 33 (2): 179–192. doi:10.1080/01596306.2012.666074.

INDEX

© The Editor(s) (if applicable) and The Author(s) 2017
S. Riddle and D. Cleaver, *Alternative Schooling, Social Justice and Marginalised Students*, Palgrave Studies in Alternative Education, DOI 10.1007/978-3-319-58990-9

Printed by Printforce, the Netherlands